POSTCARD HISTORY SERIES

The Blue Ridge Mountains of North Carolina

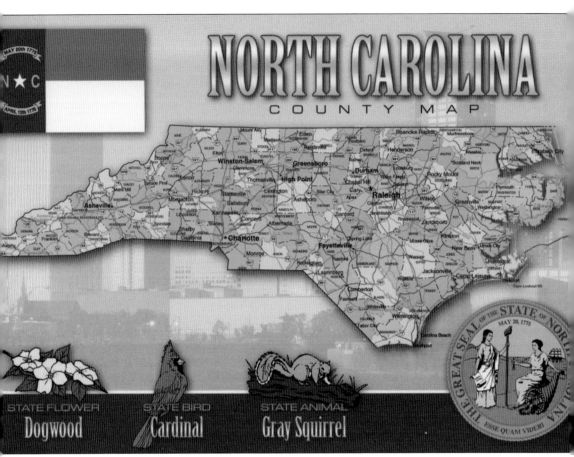

NORTH CAROLINA COUNTY MAP. This glossy postcard shows each of North Carolina's 100 counties. This vintage postcard book covers the 23 most western of those counties. Those counties are either mountainous or a combination of mountains and terrain that gradually descends to the Piedmont section of the state. Those transitional counties are known as the foothills. (Author's collection.)

ON THE FRONT COVER: WISEMAN'S VIEW OVERLOOKING LINVILLE GORGE. From Wiseman's View, one can see Table Rock Mountain, Hawksbill Mountain, the Chimneys, and Sitting Bear Mountain. Linville River flows at the base of the gorge. Wiseman's View, which is accessed via old NC Highway 105 and was named for Lafayette Wiseman, is a favorite place from which to see the mysterious Brown Mountain Lights. This is a linen–finish postcard. (Author's collection.)

ON THE BACK COVER: MOTHER BLACK BEAR WITH CUBS. A mother black bear usually gives birth to two or three cubs every other winter. The Great Smoky Mountains range boasts an impressive variety of animal species: 66 mammals, more than 240 birds, 43 amphibians, 60 fish, and 40 reptiles. This is a linen–finish postcard. (Author's collection.)

POSTCARD HISTORY SERIES

The Blue Ridge Mountains of North Carolina

Janet Morrison

ARCADIA
PUBLISHING

Published by Arcadia Publishing
Charleston, South Carolina

Printed in the United States of America

Library of Congress Control Number: 2013957397

For all general information contact Arcadia Publishing at:
Telephone 843-853-2070
Fax 843-853-0044
E-mail sales@arcadiapublishing.com
For customer service and orders:
Toll-Free 1-888-313-2665

Visit us on the Internet at www.arcadiapublishing.com

This book is dedicated to the memory of the late Lila Mae Dulin. This dear aunt was the closest thing to a grandmother I ever had. I inherited her love for postcards, and in her later years, I received her extensive postcard collection. If not for her collection, this book would not have been possible.

CONTENTS

ACKNOWLEDGMENTS

Many individuals helped make this book of vintage postcards possible. Some pointed me in the direction I needed to go in order to do my own research, while others sent me quotes from books I did not have at my disposal.

Phyllis Ciano, museum coordinator at Banner House Museum in Banner Elk, North Carolina, graciously sent me background information about the Pinnacle Inn. The details she sent me from *Banner Elk, North Carolina: A Guide to the Town and Its Historic Places*, compiled by the Greater Banner Elk Heritage Foundation and financed through the Banner Elk Tourism and Development Authority, enabled me to include my two Pinnacle Inn postcards in this book.

Bonnie Hillyer of Harrisburg, North Carolina, helped me find the information I needed in order to write the history of some of the buildings at Lake Junaluska Conference and Retreat Center.

Shannon Ames, director of community and stockholder relations for Brookfield Renewable Energy Group in Marlborough, Massachusetts, verified that a postcard labeled as "Topoco Dam" was actually Cheoah Dam. Without her assistance, I would have been on shaky ground to include that postcard in the book.

I owe my sister, Marie Morrison of Harrisburg, North Carolina, a debt of gratitude for her moral support, proofreading, and patience as I worked on this book. I dominated our computer for weeks on end, and she never once complained about that or the stacks of postcards all over the house. All images appear courtesy of the author, and all images were originally in color except where noted.

INTRODUCTION

The Blue Ridge Mountains, which once served as a physical barrier between North Carolina and the great unknown, now beckon visitors from all over the world. Running along the ridge of the Blue Ridge Mountains, the Blue Ridge Parkway appears to hold the mountains together like a ribbon on a precious package.

A wide range of plants and wildlife inhabits the mountains, some of which are found nowhere else on earth. These mountains are sprinkled with some of the most rugged gorges, beautiful waterfalls, and highest peaks in the Eastern United States. National forests cover more than a million acres in the region.

The parkway was a gift that the greatest generation gave to the people of the United States. Although it displaced families, subsequent generations have enjoyed the peace and quiet, solitude, and beautiful vistas provided by the road and its right-of-way, which are maintained by the National Park Service. Begun in 1935, the majority of the construction work was done by private companies under federal contract; however, members of several Civilian Conservation Corps camps did much landscaping and cleanup.

The topography of Western North Carolina provides a healthy habitat for many plants and animals. The climate offers lowlanders a respite from summer heat and snow skiers frostbite warnings in the winter. Such extremes in weather conditions have produced a rugged native population that is a mixture of Eastern Band Cherokee Indians, whose ancestors lived in harmony with nature for centuries, and the descendants of Scots-Irish settlers of the 18th century.

The Appalachian and Blue Ridge Mountains of North Carolina can be divided by subranges and other natural divisions. For this book, the 23 counties in the western part of the state have been divided into seven chapters.

The first chapter focuses on the northwestern corner of the state, which has adopted the name "High Country." This section is home to a number of ski resorts and such iconic attractions as Grandfather Mountain and Mount Mitchell. The Black Mountains, which get their name from the dark green spruce and fir that give them a dark look from a distance, provide the highest elevations in this section of the Blue Ridge Mountains.

The region of the Blue Ridge Mountains south of Mount Mitchell adopted the label "Land of the Sky" early in the 20th century and is the focus of the second chapter. Asheville is the crown jewel of the area.

The third chapter of this book looks at the Great Balsams and Plott Balsams, two subranges of the Blue Ridge Mountains. The Great Balsams range is named for the spruce and fir trees found there. The Blue Ridge Parkway reaches its highest elevation at Richland Balsam in the Great Balsams. The Blue Ridge Parkway ends (or begins, if one is traveling north) at Soco Gap in the Plott Balsams.

Great Smoky Mountains National Park and the Qualla Boundary are the focus of the fifth chapter. Although Great Smoky Mountains National Park straddles the North Carolina-Tennessee state line, the entire park is included in this book. The Qualla Boundary is the home of the Eastern Band Cherokee Indians. It is not a reservation. It is land held in trust by the federal government. The Cherokee people have made these mountains their home since ancient times, and their language has played heavily in the naming of places in the western part of the state.

A movement to establish a national park in the Great Smoky Mountains took hold in the 1920s but creating the park was not simple. Its 800 square miles or 507,869 acres lie in North Carolina and Tennessee and consist of 6,600 private tracts of land.

Both those states and private citizens donated millions of dollars to create Great Smoky Mountains National Park. It was the first national park given to the US government by the people. It seems appropriate, therefore, that it is the most visited national park in the country.

The Great Smoky Mountains are called "smoky" due to the fog that rises from the valleys and mountainsides. The range is home to the largest stand of old-growth trees in the Eastern United States.

Like the higher elevations of the Black Mountains, nearly all Great Smoky Mountains National Park's mature Fraser fir trees have fallen victim to the balsam woolly adelgid.

After numerous skirmishes with European settlers in the late 1700s and early 1800s, in 1838, Pres. Andrew Jackson signed the Removal Act, which mandated the forced removal of the Cherokee people from the mountains of North Carolina to the Oklahoma Territory. This forced march is called the Trail of Tears due to the thousands of Cherokee who died on that journey. This was done in spite of the fact that the Cherokee people had a written constitution, a bilingual newspaper, and a number of Christian churches in which they sang hymns in their native language. A remnant of the Cherokee people stayed behind and hid in the mountains. Today, thousands of their descendants live on the Qualla Boundary.

The Snowbird Mountains and southwestern corner of North Carolina are featured in chapter five of this book. The least well-known section of the mountains in the state includes the Nantahala National Forest and Fontana Dam. The area attracts hikers and whitewater enthusiasts.

The Nantahala National Forest covers 500,000 acres. "Nantahala" is Cherokee for "land of the noonday sun." Due to the gorges and steep valleys in these mountains, the sun only hits the bottom of some of the valleys in the middle of the day. This is a rugged area. Elevation in the forest ranges from 1,200 to 5,800 feet.

The Joyce Kilmer-Slickrock Wilderness contains 13,000 acres in the Snowbirds area. The Joyce Kilmer Memorial Forest was named for Kilmer, a 165th Infantry, Rainbow Division, soldier and poet who was born in New Brunswick, New Jersey, in 1886 and was killed in action in France on June 30, 1918. This old-growth forest consists of more than 100 species of trees. Some of the largest of the trees are hemlocks, red oaks, and poplars.

The sixth chapter of this book takes a look at the "Land of Waterfalls." Although waterfalls are found throughout the mountains of North Carolina, some of the most famous of them are located in this southern section that stretches from Macon County to Polk County.

The gradual drop in elevation in the Blue Ridge Mountains gives way to a region of lesser mountains and rolling hills that offer a transition into the Piedmont section of North Carolina. That area is called the foothills and is the focus of the last chapter in this book.

Some chapter divisions are more distinct than others. Due to elevation differences, several counties were divided between two chapters.

One

HIGH COUNTRY

The counties in the northwestern corner of North Carolina are collectively known as the High Country. It is a region that boasts being "where spring comes and spends the summer."

The High Country, for purposes of this book, encompasses the following counties: Alleghany, Ashe, Avery, Mitchell, Watauga, Wilkes, Yancey, the Linville Gorge portion of Burke County, and the Blowing Rock part of Caldwell County.

The Blue Ridge Mountains, as well as the Brushy Mountains and Black Mountains subranges, are found here. The Black Mountains have the highest mountains east of the Mississippi River. The High Country experiences harsh weather most winters. Grandfather Mountain and Mount Mitchell have both recorded extreme cold temperatures and wind speeds.

The Blue Ridge Parkway weaves its way through the High Country and lies like a ribbon along the crest of the Blue Ridge. Construction of the scenic highway began in 1935 and was completed in 1967 except for the "missing link" on Grandfather Mountain. The one-quarter-mile long Linn Cove Viaduct at milepost 304 completed that missing link in 1987. Special engineering and design work were necessitated by the fragile geology of Grandfather Mountain.

Linville Gorge Wilderness covers nearly 12,000 acres in Pisgah National Forest in Burke County. The Linville River winds its way some 1,400 to nearly 2,000 feet below the surrounding mountain ridges. The gorge lures hikers and campers, some of whom have had to be rescued from the unforgiving terrain.

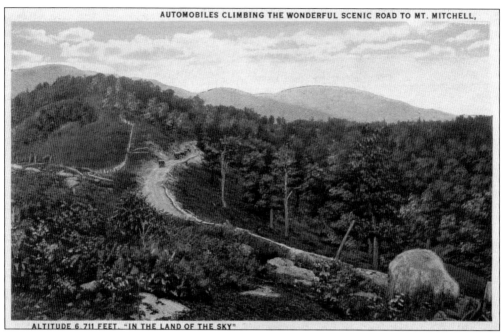

ALTITUDE 6,711 FEET. "IN THE LAND OF THE SKY"

AUTOMOBILES CLIMBING MOUNT MITCHELL. This matte-finish postcard is a treasure because it depicts a line of early black automobiles making their way up an unpaved road on the tallest mountain east of the Rockies. Mount Mitchell's elevation is 6,684 feet. Splashes of color appear in the bushes and trees in the photograph.

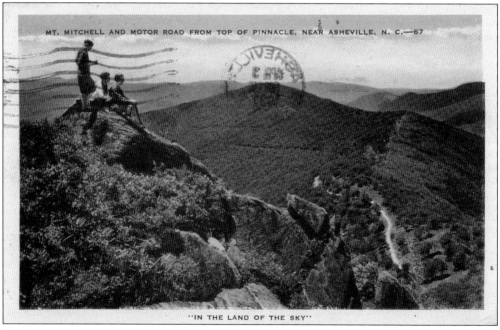

MT. MITCHELL AND MOTOR ROAD FROM TOP OF PINNACLE, NEAR ASHEVILLE, N. C.—67

"IN THE LAND OF THE SKY"

FROM THE TOP OF MOUNT MITCHELL. This matte-finish postcard was postmarked in 1930. It shows an amazing green landscape prior to the arrival of the balsam woolly adelgid. The European insect is killing the Fraser fir forest. This view also shows how far below the Mount Mitchell summit the roadway was.

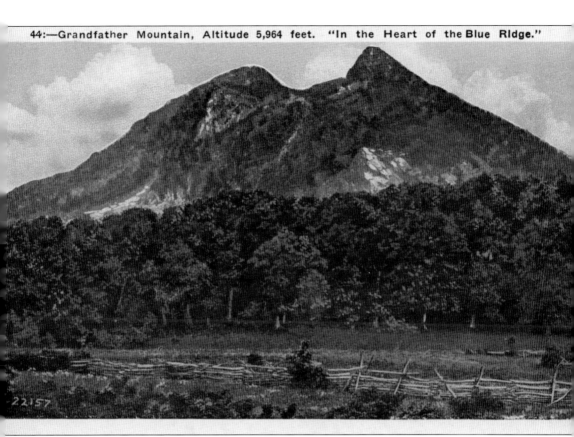

44:—Grandfather Mountain, Altitude 5,964 feet. "In the Heart of the Blue Ridge."

MAJESTIC GRANDFATHER MOUNTAIN. This matte-finish postcard dates from the early 1900s. Grandfather Mountain takes its name from the fact that it looks like the profile of an old man's face from a certain angle. The opening of the Linn Cove Viaduct on the mountain in 1987 meant that the 470-mile-long Blue Ridge Parkway, which stretches from Skyline Drive in Virginia to Great Smoky Mountains National Park in North Carolina, was completed 52 years after it was begun. Linn Cove Viaduct consists of 153 fifty-ton segments that rest atop seven piers that are anchored into the slopes of the mountain. The United Nations Educational, Scientific, and Cultural Organization named Grandfather Mountain a member of the international network of Biosphere Reserves in 1992 because it supported 42 rare and endangered species. The State of North Carolina agreed to purchase 2,456 acres of land in 2008 and created Grandfather Mountain State Park. The Nature Conservancy holds conservation easements on nearly 4,000 additional acres. More information is available at www.grandfather.com.

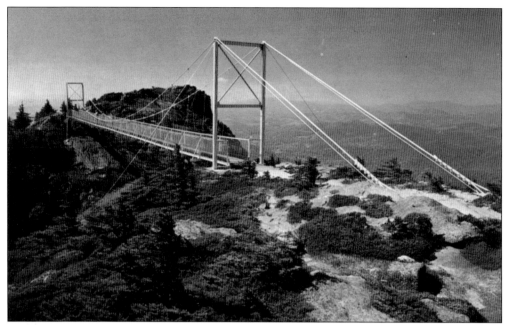

MILE HIGH SWINGING BRIDGE. These glossy postcards probably date from the early 1960s. The 228-foot suspension bridge on Grandfather Mountain was dedicated September 2, 1952. It spans an 80-foot chasm and gets its name from the fact that it is more than a mile in elevation. It is called a swinging bridge because suspension bridges sway. The original bridge, pictured here, cost $15,000 to build. It was fabricated in Greensboro and reassembled on the mountain. It was rebuilt in 1999 at a cost of $300,000, according to the www.grandfather.com website. The cables, floorboards, and side rails were replaced with galvanized steel. This eliminates the need for repainting.

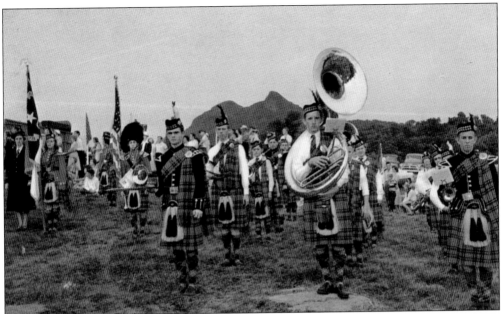

GRANDFATHER MOUNTAIN HIGHLAND GAMES. This glossy postcard dates from about 1960. The Grandfather Mountain Highland Games and Gathering O' Scottish Clans have been held in July every year since 1955. These world-famous Scottish Games draw huge crowds to hear the bagpipes, watch dancers compete in the Highland Fling and the Sword Dance, and watch the "heavy" athletic events, such as tossing of the caber.

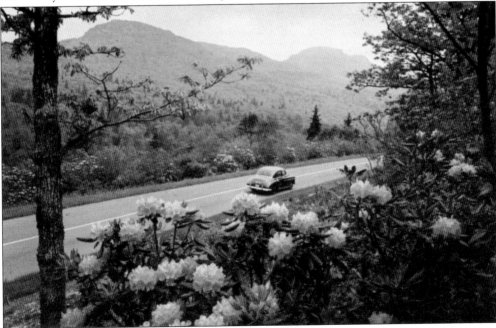

BLUE RIDGE PARKWAY NEAR GRANDFATHER. This glossy postcard dates from the late 1950s, from the looks of the automobile pictured. Pink rhododendrons bloom in the foreground. Until the Linn Cove Viaduct was built, motorists had to exit the Blue Ridge Parkway and take a non-parkway route around Grandfather Mountain before getting back on the parkway.

13

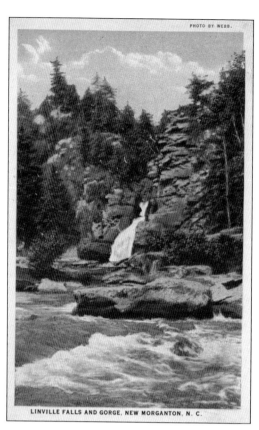

LINVILLE FALLS AND GORGE, NEW MORGANTON, N. C.

LINVILLE FALLS NEAR MORGANTON.
Unusual for North Carolina, Linville Falls is a caprock waterfall, meaning the top layer of rock is harder than the underlying stone. Erosion undercuts such falls causing chunks of the upper rock to break off. This results in the waterfall migrating upstream over time. Due to its being a caprock waterfall, it is believed that Linville Falls was once 12 miles downstream from its present location. It cut Linville Gorge as the rock eroded and broke off and the waterfall receded. The upper section of Linville Falls has a 12-foot drop and the lower portion has a 60-foot drop. The postcard at left is a matte-finish one probably from the 1930s or 1940s. The postcard below is glossy and probably dates from about 1960.

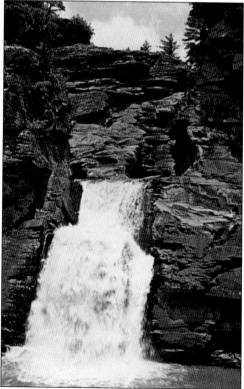

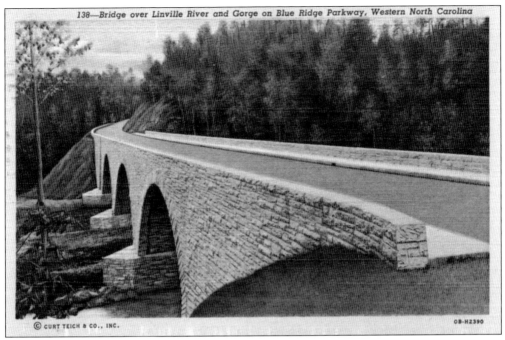

© CURT TEICH & CO., INC. OB-H2390

LINVILLE RIVER BRIDGE ON PARKWAY. This is a linen-finish postcard. The triple-arch stone-face Blue Ridge Parkway bridge over Linville River, just above Linville Falls, is striking in its design but typical of the stone bridges on the parkway. Stone from local quarries up and down the parkway was used when possible in the roadway's construction.

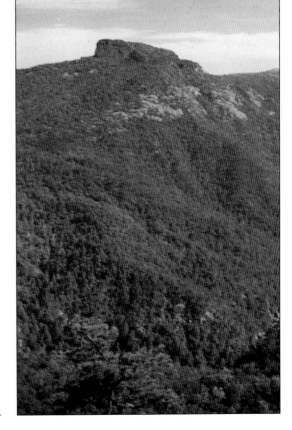

TABLE ROCK MOUNTAIN. Table Rock Mountain is on the eastern rim of Linville Gorge near Linville Falls in Burke County. It has an elevation of 3,950 feet. It is said that the Cherokee people called Table Rock Attacoa and that they used it as an altar in some of their sacred ceremonies. This glossy postcard probably dates from about 1960.

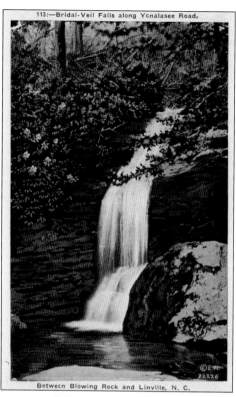

113:—Bridal-Veil Falls along Yonalasee Road.

Between Blowing Rock and Linville, N. C.

BRIDAL VEIL FALLS ALONG YONALASSEE ROAD. This Bridal Veil Falls, located between Blowing Rock and Linville, is not to be confused with the more-famous Bridal Veil Falls near Highlands, North Carolina. This one is identified on the matte-finish postcard as being on Yonahlossee Road, which became US Highway 221.

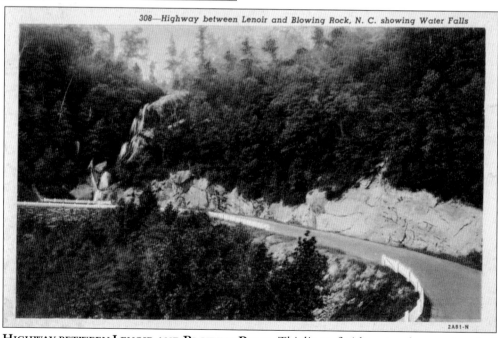

308—Highway between Lenoir and Blowing Rock, N. C. showing Water Falls

HIGHWAY BETWEEN LENOIR AND BLOWING ROCK. This linen-finish postcard was postmarked in 1947. A toll road was constructed between Lenoir and Blowing Rock in 1850. That road eventually became US Highway 321 in the 1900s. The highway has been widened multiple times over the years. Extensive improvements were made to it in the early 2000s.

THE BLOWING ROCK. The legend behind the Blowing Rock is that a American Indian man leapt off the rock into the gorge below while trying to choose between staying with his ladylove and returning to his tribal duty. As the legend goes, the maiden asked the Great Spirit to return him to her, and the winds of Johns River Gorge blew him back into her arms. The flume formed by the rocky walls of the gorge funnels the northwest wind up with sufficient force to return light objects thrown off the rock. The legend and other facts about the Blowing Rock can be found on the www.blowingrock.com and www.townofblowingrock. com websites. The postcard at right is a matte-finish one, postmarked in 1924. The postcard below is glossy and dates from about 1960.

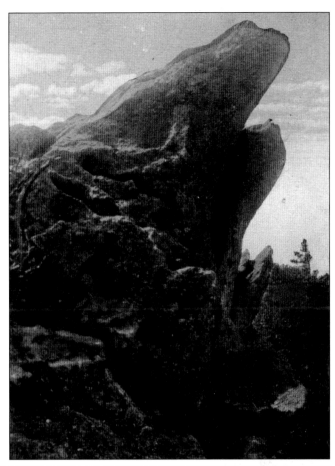

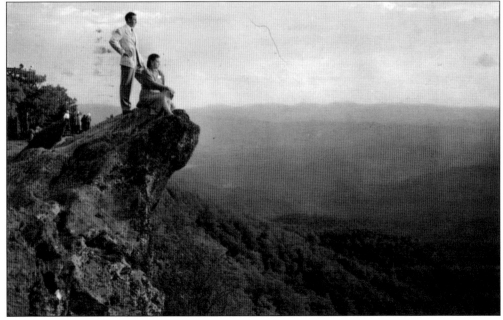

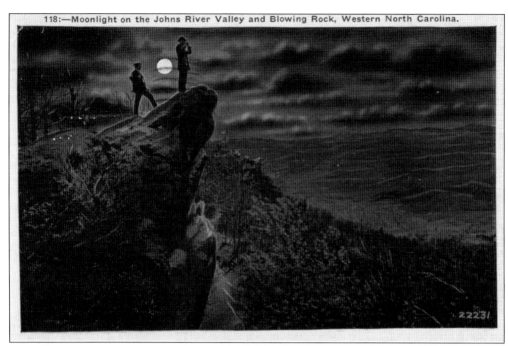

118:—Moonlight on the Johns River Valley and Blowing Rock, Western North Carolina.

MOONLIGHT ON JOHNS RIVER VALLEY. This linen-finish postcard was postmarked in 1937. The Blowing Rock stands at an elevation of 4,000 feet and hangs over the 3,000-foot-deep Johns River Gorge. In daylight, Hawksbill Mountain and Table Rock Mountain are visible to the southwest. Grandfather Mountain stands to the west.

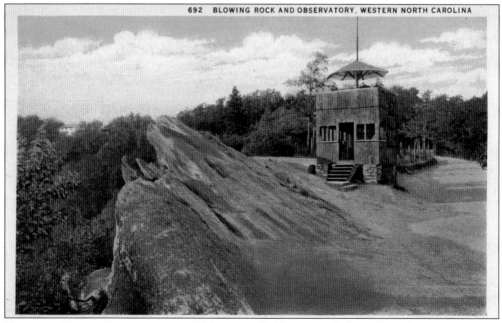

692 BLOWING ROCK AND OBSERVATORY, WESTERN NORTH CAROLINA

BLOWING ROCK OBSERVATORY. This matte-finish postcard dates from before 1930. No information about the observatory has been found, but it stands to reason that the Blowing Rock would have been a perfect location for an observatory in the days before electric house lights and streetlights came into general use.

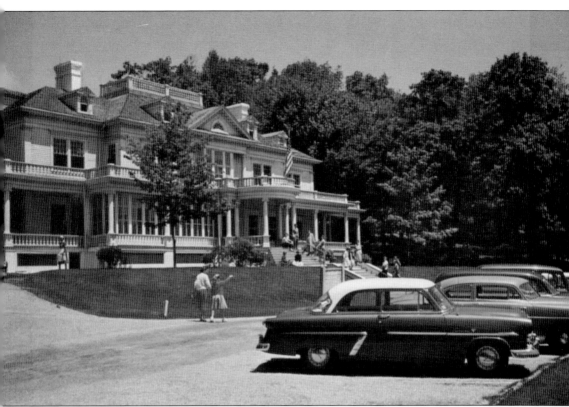

THE CONE ESTATE, BLOWING ROCK. Export businessman and textile man Moses H. Cone and his wife, Bertha, acquired the 3,516 acres that make up the Cone Estate over a period of 35 years, although most of it was bought in the 1890s. The estate included a huge orchard, a dairy, three lakes, and a network of roads built under Cone's supervision. The Cones began building the Manor House in 1899. Some 30 of the subsistence farmers from whom the Cones purchased property stayed on as tenants and employees on the estate. Moses Cone died at the age of 51 in 1908. The estate and house are now under management of the National Park Service. More fascinating facts about the estate can be found in *Historic Resource Study, Moses H. Cone Estate,* by Barry M. Buxton. This glossy postcard dates from the 1950s.

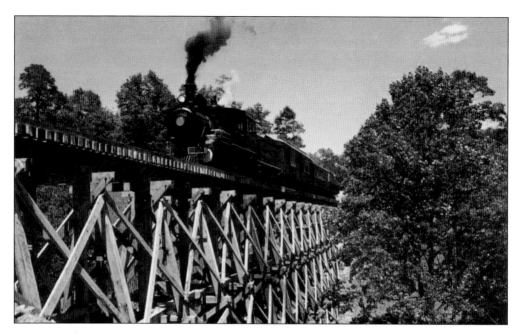

TWEETSIE RAILROAD, BLOWING ROCK. *Tweetsie* is a restored narrow-gauge steam train used solely for recreational purposes today. *Tweetsie* ran between Johnson City, Tennessee, and Boone, North Carolina, from 1918 until the flood of 1940. It was an extension of the East Tennessee & Western North Carolina Railroad. The tracks ran up Rivers Street in Boone. Tweetsie Railroad Wild West Theme Park opened in 1957 and includes a reproduction Western village in addition to the train ride. *Tweetsie* takes passengers on a three-mile route that has thrilled visitors for generations. Fred Kirby, a singing cowboy, made personal appearances at Tweetsie Railroad Wild West Theme Park for decades. These glossy postcards date from the 1960s.

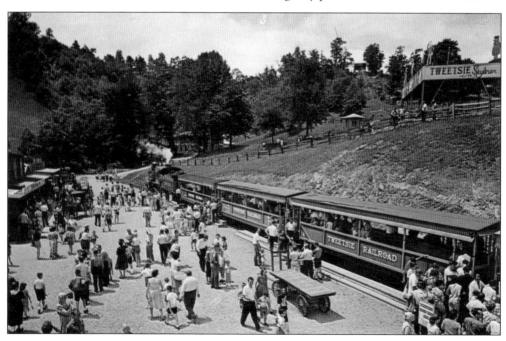

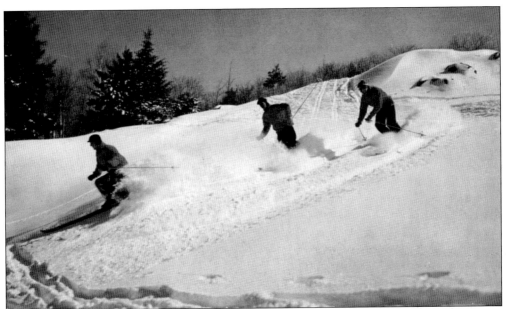

SKIING IN NORTH CAROLINA. It was in the 1960s that the first ski slopes were developed in North Carolina, thanks to snowmaking machines. Snow skiing is a popular winter sport in North Carolina and is enjoyed at the following commercial ski resorts: Appalachian Ski Mountain, Beech Mountain Resort, Cataloochee Ski, Sapphire Ski Resort, Sugar Mountain Resort, and Wolf Ridge Ski Resort. This glossy color postcard probably dates from the 1960s.

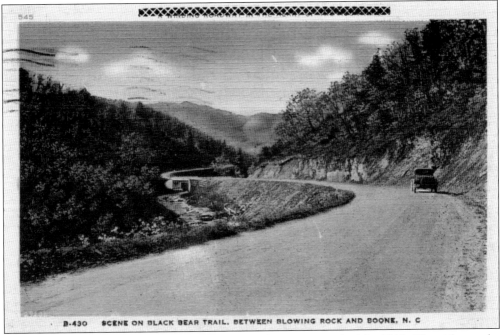

BLACK BEAR TRAIL. This linen-finish postcard was postmarked in 1944. The title on the postcard is "Scene on Black Bear Trail, Between Blowing Rock and Boone, N.C." The www. NewRiverNotes.com website states that Black Bear Trail is now US Highway 321. That road between Blowing Rock and Boone is now a four-lane highway.

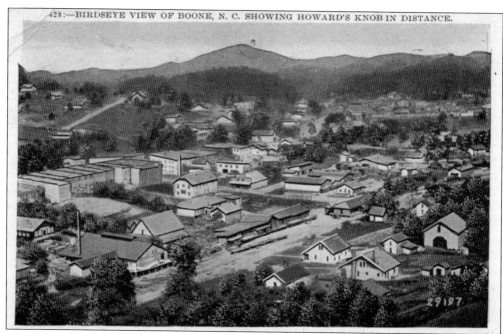

BIRD'S-EYE VIEW OF BOONE. Rich Mountain and Howard's Knob can be seen behind the town of Boone. Although the US Geological Survey gives the proper name as Howard Knob, locals and students at Appalachian State University know it as Howard's Knob. John Preston Arthur's 1915 book *A History of Watauga County with Sketches of Prominent Families* includes information about Daniel Boone and Benjamin Howard's association with Boone. Howard's Knob was named for Benjamin Howard. Boone, Howard, and other hunters stayed in a cabin near present-day Justice Hall on the university's campus. The elevation of Howard's Knob is 4,396 feet, while that of Boone is 3,333 feet. The postcard above is matte-finish and was postmarked in 1930. According to the www.NewRiverNotes.com website, it is a hand-painted watercolor postcard from about 1910. The postcard below has a linen finish and was postmarked in 1955.

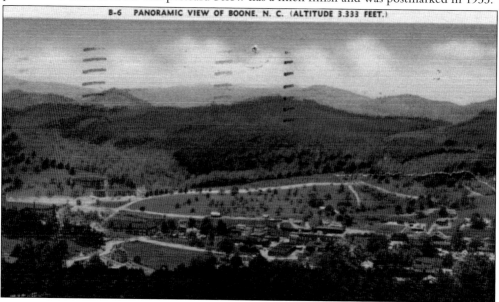

B-6 PANORAMIC VIEW OF BOONE, N. C. (ALTITUDE 3.333 FEET.)

APPALACHIAN STATE TEACHERS COLLEGE MOUNTAINEERS. This black, gold, and white postcard shows the school colors of Appalachian State Teachers College in Boone along with the school's mountaineer mascot, called Yosef. The postcard dates from 1964, before the school gained university status. Appalachian State University is a campus of the University of North Carolina system. It sits in the valley below 5,377-foot-high Rich Mountain.

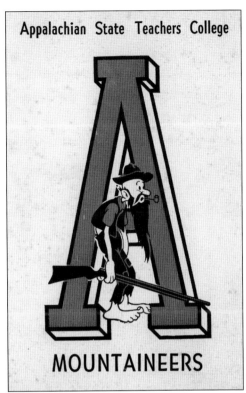

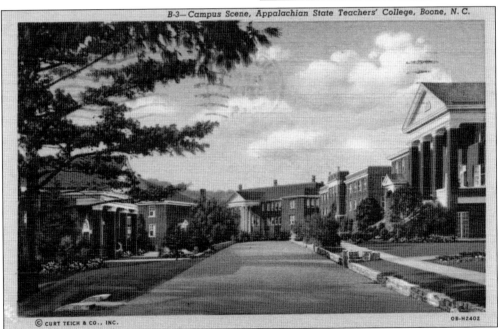

APPALACHIAN CAMPUS SCENE. This Appalachian State Teachers College linen-finish postcard was postmarked in 1955. The building on the far left was Central Dining Hall, later named Welborn Cafeteria, which was constructed in 1925. The structure in the center of the picture was the second Administration Building. It was built in 1924.

APPALACHIAN STATE'S ADMINISTRATION BUILDING. The second Administration Building at Appalachian State Teachers College was destroyed by fire December 29, 1966. The *Watauga Democrat* newspaper in Boone reported that the building housed the foreign language and English departments in addition to the administration offices. Many valuable records of the college were lost.

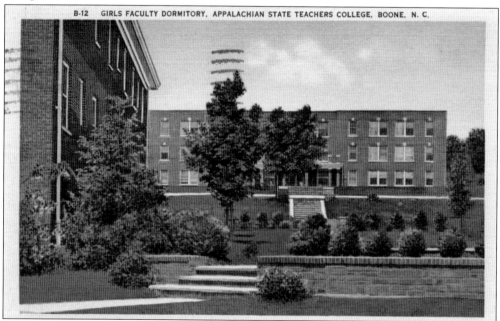

APPALACHIAN FACULTY HOUSING. This building was completed in 1938 and was the first housing for faculty at Appalachian State Teachers College in Boone. It was designed with eight apartments and 30 single rooms for faculty and staff. In 1953, it was converted into a dormitory for women students and renamed North Hall. It was demolished in 1993 so Plemmons Student Union could be expanded.

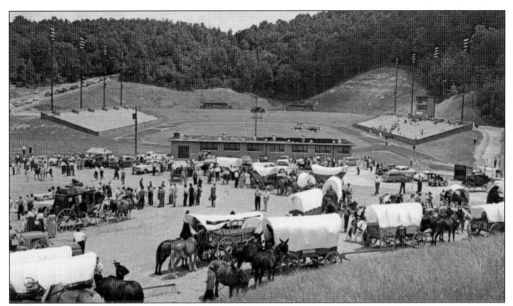

DANIEL BOONE WAGON TRAIN. To celebrate the 300th anniversary of the Carolina Charter in 1963, residents of Watauga, Wilkes, and other counties restaged Daniel Boone's wagon train across the Blue Ridge Mountains. The four-day reenactment terminated at Conrad Stadium on the campus of Appalachian State Teachers College. Randell Jones reported in the *Watauga Democrat* that this trip was repeated every summer through 1973.

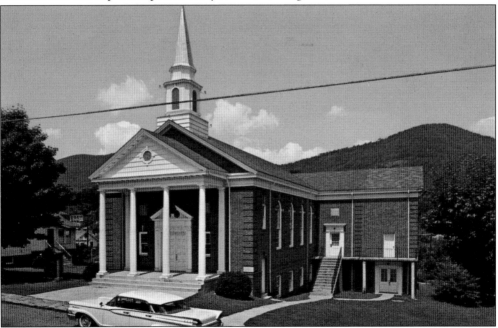

BOONE'S FIRST PRESBYTERIAN CHURCH. This glossy postcard was postmarked in 1964. Founded in 1939, the First Presbyterian Church sanctuary pictured here was located on East Howard Street. The congregation worshipped there until 2011, when they built a new sanctuary on Big Valley Street, according to the church's website. In 2009, Appalachian State University purchased the church's property on East Howard Street for campus expansion.

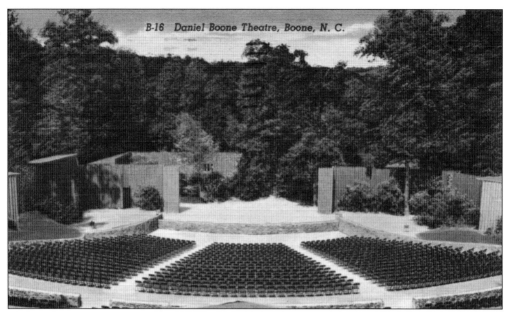

DANIEL BOONE THEATRE. This linen-finish postcard was postmarked in 1955. Daniel Boone Theatre's 2,500-seat amphitheater is home to the outdoor drama *Horn in the West* in Boone every summer. John Lippard and design students from North Carolina State University designed the theater. It was built in three months in 1952. Additional information about the theater can be found on the website of the *Horn in the West*.

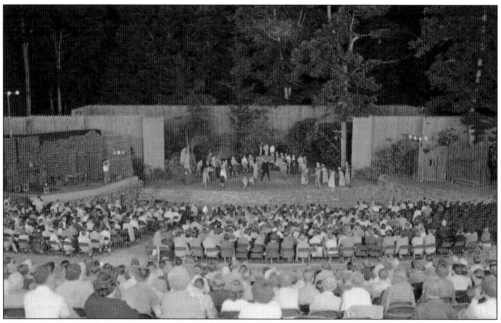

HORN IN THE WEST. *Horn in the West*, an outdoor drama, was written by the late Dr. Kermit Hunter, who studied under Dr. Paul Green at the University of North Carolina at Chapel Hill. According to the www.HornInTheWest.com website, Glenn Causey "began performing in the drama on its opening night in 1952. From 1956 until 1996, he played the character of Daniel Boone without missing a single performance."

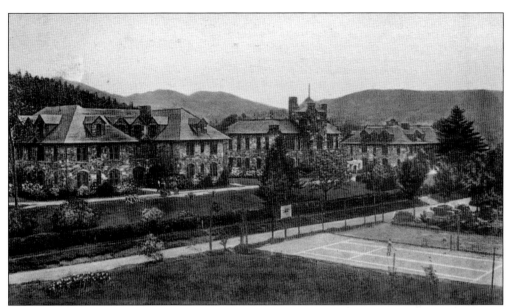

PINNACLE INN, BANNER ELK. *Banner Elk, North Carolina: A Guide to the Town and Its Historic Places*, compiled by the Greater Banner Elk Heritage Foundation, states the following about Pinnacle Inn: "In the summer of 1932 Lees-McRae opened a resort inn in Tennessee dorm. Called the Pinnacle Inn, it was staffed by LMC students who earned money for tuition and gained business experience in the tourism industry. The Pinnacle Inn included a well appointed dining hall on the ground floor and handmade furnishings produced in the college woodworking and metal shops. Guests enjoyed the bounty of the college run farm, tennis, fishing and hiking on the Elk River, and game bird hunting on college lands. Today the Pinnacle Inn serves Lees-McRae College as the Business Department faculty offices." These matte-finish postcards date from the 1940s.

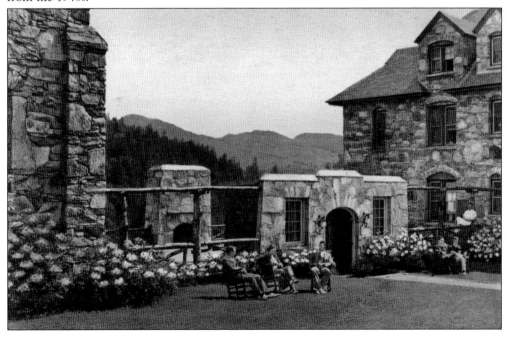

HOTEL TUCKER, WEST JEFFERSON. This is a grey-tones postcard on heavy beige cardstock. West Jefferson is the county seat of Ashe County. The town has an arts district and a cheese and butter factory, both of which attract tourists year-round. Hotel Tucker was located at an elevation of 3,100 feet at First and Church Streets in West Jefferson, according to the www. main.nc.us website.

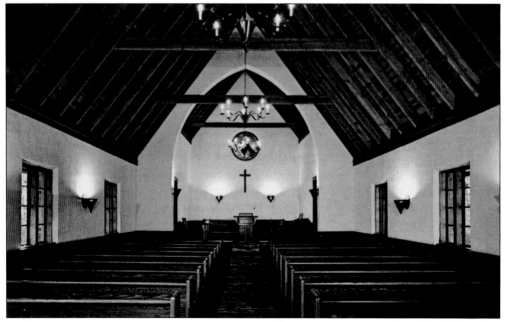

ROARING GAP COMMUNITY CHAPEL. Roaring Gap in Alleghany County takes its name from the sound the wind makes coming through this mountain gap, according to William S. Powell's book *The North Carolina Gazetteer: A Dictionary of Tar Heel Places.* Industrialist Alexander Chatham established Roaring Gap as a resort in 1890. This glossy postcard was postmarked in 1976.

Two

LAND OF THE SKY

For purposes of this book, Land of the Sky includes the following counties: Buncombe, McDowell, Madison, portions of Haywood, and the higher elevations of Rutherford.

The city of Asheville is the hub of the region known as Land of the Sky. The city is surrounded by 500,000-acre Pisgah National Forest and sits just off the Blue Ridge Parkway.

After the railroad made the area more accessible in the 1880s, wealthy people such as George W. Vanderbilt discovered the beauty and comfortable climate of Asheville. Vanderbilt's 250-room French chateau on the outskirts of Asheville draws thousands of visitors year-round.

The town of Hot Springs in Madison County grew up as a result of the thermal waters of the springs there. European settlers started capitalizing on the springs in the early 1800s and built hotels there. On the Cincinnati-Charleston branch of the Southern Railway, the town is adjacent to Great Smoky Mountains National Park and lies along the Appalachian Trail.

Several religious and other organizations have been attracted to the beauty and pleasant summer temperatures in this section of the mountains. Montreat is home to a conference center for the Presbyterian Church (USA), and Lake Junaluska, near Waynesville, is an assembly grounds for the United Methodist Church.

Some of the most dramatic parts of the Blue Ridge Parkway are south of Asheville as the highway passes Mount Pisgah and tunnels through numerous mountains.

In Rutherford County, the Carolina Mountain Power Company built a dam on the Broad River to create hydroelectric power. The resulting body of water, Lake Lure, was completed in 1927 and has provided a backdrop for many movies.

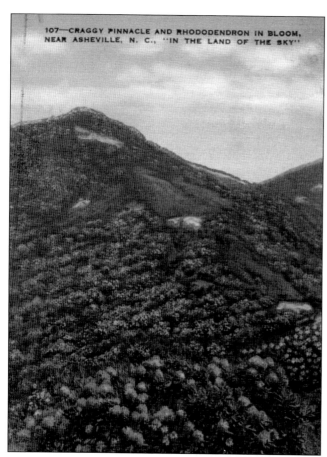

107—CRAGGY PINNACLE AND RHODODENDRON IN BLOOM, NEAR ASHEVILLE, N. C., "IN THE LAND OF THE SKY"

CRAGGY PINNACLE AND RHODODENDRONS. Craggy Pinnacle is a peak in the Black Mountains along the Blue Ridge Parkway and is known for an abundance of rhododendrons. These are the highest and largest gardens of their kind in the world, covering 600 acres on the tops of the Craggy range. It is a popular area for hikers. Craggy Mountain Tunnel is located at milepost 364.4 on the Blue Ridge Parkway. This linen-finish postcard was postmarked in 1939.

CRAGGY GARDENS. The Craggy Mountains and Craggy Gardens are approximately 17 miles northeast of Asheville at milepost 364 on the Blue Ridge Parkway. The Craggy Gardens cover the slopes of the 6,085-foot-elevation Craggy Dome. The gardens are a good place to see a mass of rhododendrons in bloom. The postcard dates from about 1960.

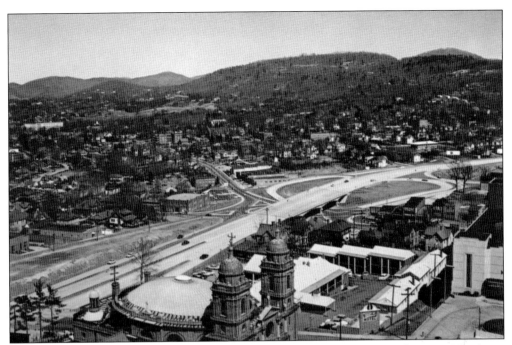

ASHEVILLE EXPRESSWAY. This glossy postcard shows the expressway interchange at Merrimon Avenue and Broadway. The two-mile-long expressway was completed in 1961 at a cost of more than $7 million. According to the description on the back of the postcard, it ran from Beaucatcher Tunnel to the Smoky Mountain Bridge.

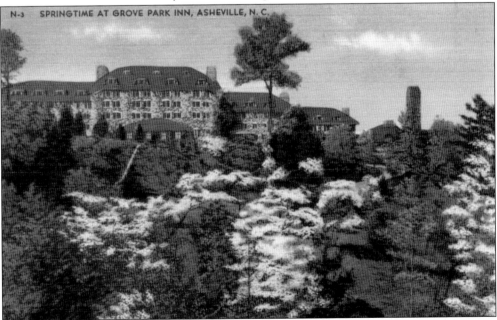

SPRINGTIME AT GROVE PARK INN. This linen-finish postcard was postmarked in 1955. After making his fortune selling Grove's Tasteless Chill Tonic, Edwin Wiley Grove purchased 408 acres of land north of Asheville in 1909 and soon realized his dream of building a world-class hotel. The Grove Park Inn opened on July 12, 1913.

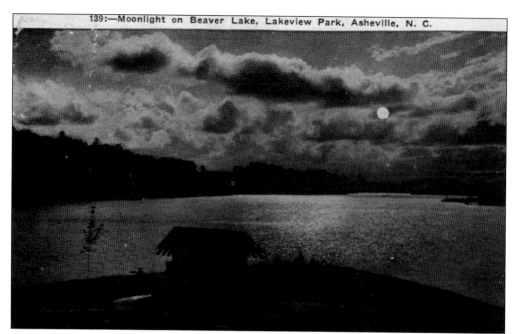

MOONLIGHT ON BEAVER LAKE. This is a matte-finish postcard. The back of the postcard describes the scene as a 61-acre "sparkling body of clear mountain water" called Beaver Lake. This early-1900s postcard boasts of unobstructed mountain views, sunsets, and moonlit nights enjoyed at the lake by Asheville residents and visitors.

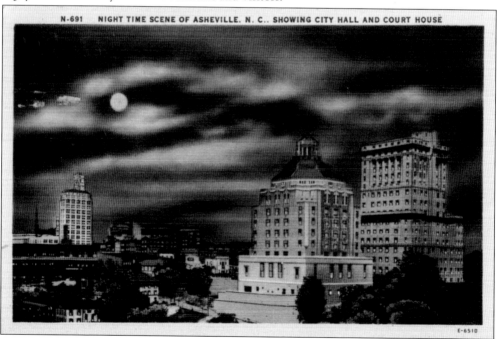

NIGHTTIME SCENE OF DOWNTOWN ASHEVILLE. This linen-finish postcard was postmarked in 1948. It shows downtown Asheville by the light of the moon with the Jackson Building predominant on the left, the Art Deco Asheville City Hall just right of center, and the Buncombe County Courthouse on the far right.

32

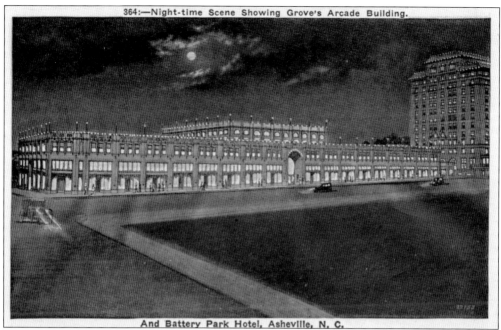

And Battery Park Hotel, Asheville, N. C.

GROVE ARCADE BUILDING. According to the www.grovearcade.com website, this 269,000-square-foot building was the brainchild of Edwin Wiley Grove. It opened in 1929 in downtown Asheville and housed a variety of shops and offices. It was taken over by the federal government in the World War II war effort, but in 2002, the restored building reopened in keeping with its original purpose. This is a matte-finish postcard.

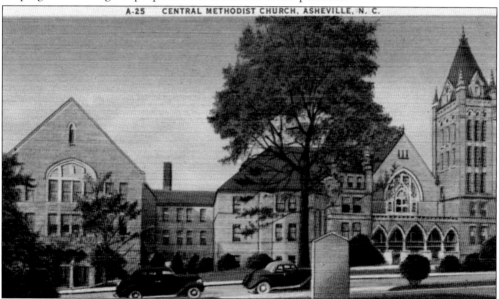

A-25 CENTRAL METHODIST CHURCH, ASHEVILLE, N. C.

CENTRAL METHODIST CHURCH, ASHEVILLE. The automobiles in the picture indicate that the postcard probably dates back to the 1930s. A circuit-riding minister organized the Methodists in Asheville in 1824, and in 1837, they built the first church of any denomination in the town. A brick sanctuary replaced the original frame structure in 1857. Construction on the sanctuary pictured here began in 1902. This is a linen-finish postcard.

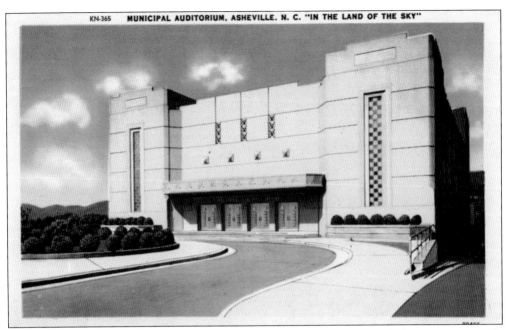

ASHEVILLE'S MUNICIPAL AUDITORIUM. This is a glossy postcard of the Art Deco–style municipal auditorium that opened in Asheville in 1940. The cost of construction was partly funded by the Works Progress Administration in an effort to put people back to work. Poor design and acoustical problems resulted in disappointment for the facility.

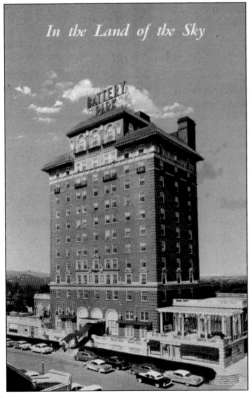

In the Land of the Sky

ASHEVILLE'S BATTERY PARK HOTEL. This glossy postcard probably dates from the 1950s. Located at 1 Battle Square at the corner of O. Henry Street, this 14-story, 220-room hotel was built by Edwin Wiley Grove. Note the Mission Revival–style roof. The hotel operated until 1972. In the 1980s, the building was converted into senior citizen apartments.

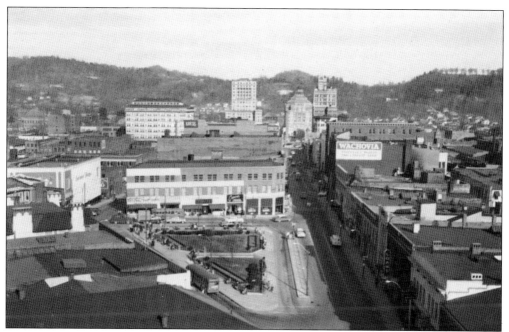

PANORAMIC VIEW OF ASHEVILLE. This glossy postcard gives a view of Asheville, looking east, probably in the late 1950s. The triangular open space in the lower-left quadrant of the picture is Pritchard Park. It is bordered by Patton Avenue and Haywood and College Streets in the Battery Park section of downtown.

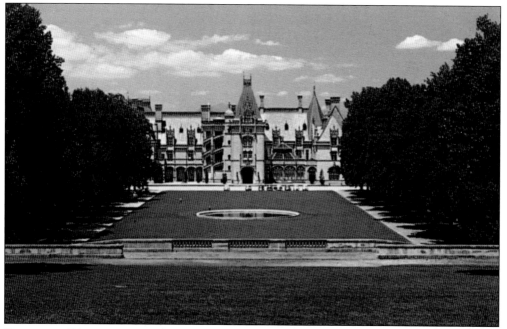

BILTMORE HOUSE FROM THE RAMPE DOUCE. This glossy postcard dates from the early 1960s. Artisans from around the world worked from 1889 until 1895 to build the Biltmore House for George Vanderbilt, who was a bachelor at the time. The 250-room residence was opened to the public in 1930 and remains a major tourist attraction today.

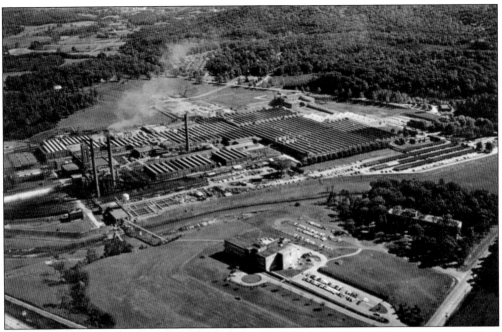

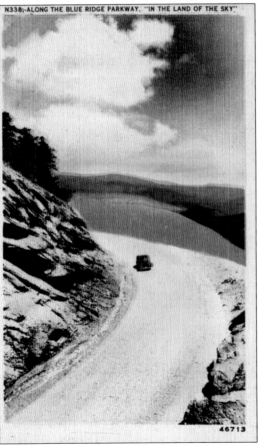

AMERICAN ENKA CORPORATION. The description on this glossy postcard reads as follows: "Aerial view of American Enka Corporation plants and offices at Enka, North Carolina just west of Asheville. Enka produces nylon and rayon and is one of the nation's leading producers of manmade fibers." A Dutch company established the plant in 1928.

ALONG THE BLUE RIDGE PARKWAY. This linen-finish postcard is somewhat unusual in that it is vertical instead of horizontal. It was postmarked in 1948. Note that the roadway does not appear to be paved, although the Civilian Conservation Corps assisted with the paving of the parkway prior to the start of World War II.

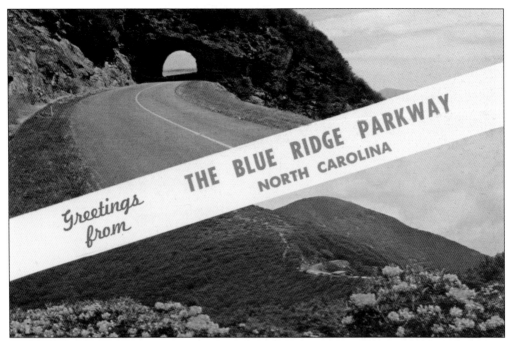

GREETINGS FROM BLUE RIDGE PARKWAY. The top of this glossy postcard shows one of the 25 tunnels on the Blue Ridge Parkway in North Carolina, and the bottom shows a view of Craggy Gardens ablaze with pink rhododendron blooms. Craggy Gardens is in Buncombe County at milepost 364. This postcard was postmarked in 1964.

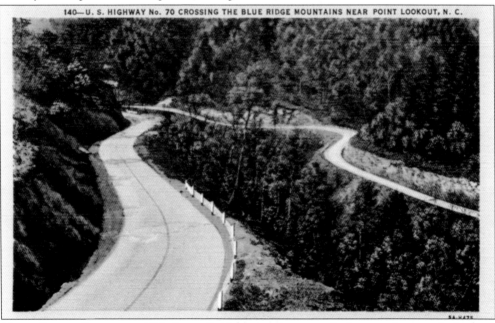

NEAR POINT LOOKOUT. This linen-finish postcard was made from a photograph showing where old US Highway 70 crossed the Blue Ridge Parkway in Buncombe County. The Point Lookout Trail now follows part of the old NC Highway 10/US Highway 70 route and part of it has been absorbed by the interstate highway system.

7A-H1743

MOUNT PISGAH BY MOONLIGHT. The Cherokee Indian name for Mount Pisgah was Elseetoss, according to the Pisgah Inn's website. One oral tradition about the naming of this 5,722-foot peak is that James Hall, a chaplain accompanying Gen. Griffith Rutherford's expedition against the Cherokees in 1776, is credited with comparing the view of Pisgah Mountain from the French Broad River valley with the "Promised Land" seen by Moses from Pisgah and described in Deuteronomy. Another tradition credits the Reverend George Newton, a Presbyterian minister who taught at what became Newton Academy in Asheville in the late 1700s and early 1800s. Like Hall, Newton was reminded of Pisgah referenced in the Bible. The peak has been called Mount Pisgah since at least 1808. When Haywood County was formed from Buncombe County that year, the mountain's ridgeline was the dividing line between the two counties. Thomas Lanier Clingman owned 300 acres on the mountain from the 1830s until selling the land to George Washington Vanderbilt in 1897. This became part of Vanderbilt's 125,000-acre estate. Edith Vanderbilt sold 80,000 acres, including Mount Pisgah, to the US Forest Service in 1914. It then became part of Pisgah National Forest. Pisgah Inn is located at milepost 408.6 on the Blue Ridge Parkway.

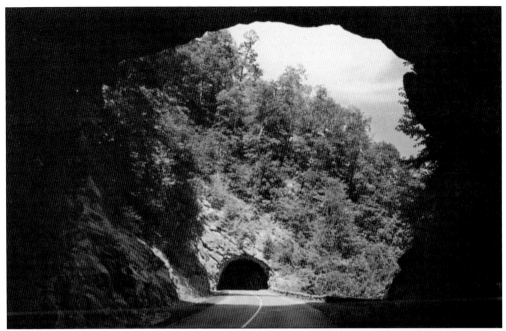

BLUE RIDGE PARKWAY TWIN TUNNELS. The photograph from which this glossy postcard was made was taken in 1957. The Twin Tunnels are at milepost 344.6 and milepost 344.7 on the Blue Ridge Parkway. This is an interesting view looking out of one of the Twin Tunnels into the other one.

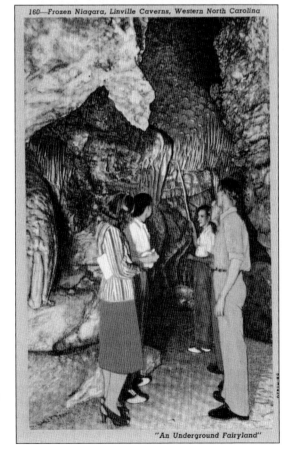

160—Frozen Niagara, Linville Caverns, Western North Carolina

"An Underground Fairyland"

FROZEN NIAGARA AT LINVILLE CAVERNS. According to the Linville Caverns website, these caverns were discovered in the early 1800s by a group of men on a fishing expedition, but Cherokee or other American Indians, no doubt, had discovered them long before that. The caverns were opened to the public in 1937.

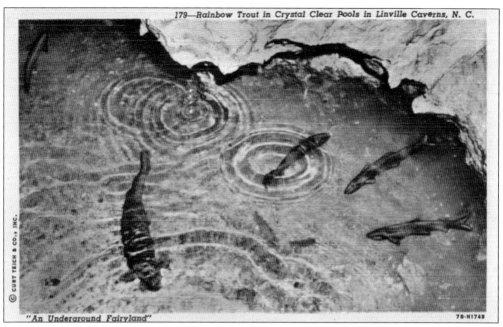

RAINBOW TROUT IN LINVILLE CAVERNS. Linville Caverns are located under Humpback Mountain in northern McDowell County. The trout that live in the river that flows through the caverns are blind, according to *Highroad Guide to the North Carolina Mountains*, by Lynda McDaniel. The temperature inside the caverns remains steady at 52 degrees Fahrenheit.

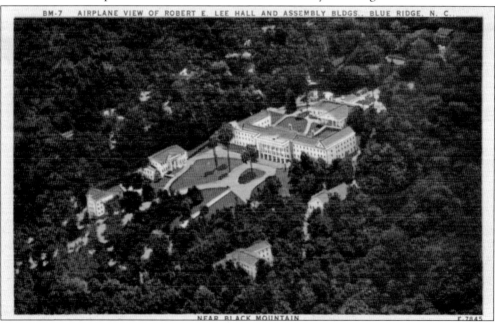

BLUE RIDGE ASSEMBLY. The Young Men's Christian Association (YMCA) owns the 1,574-acre campus of Blue Ridge Assembly near Black Mountain in Buncombe County. The facility was established in 1906 as a Christian training center. In its more than 100-year history, it has hosted conferences for many organizations, according to the assembly grounds' website. This linen-finish postcard was postmarked in 1951.

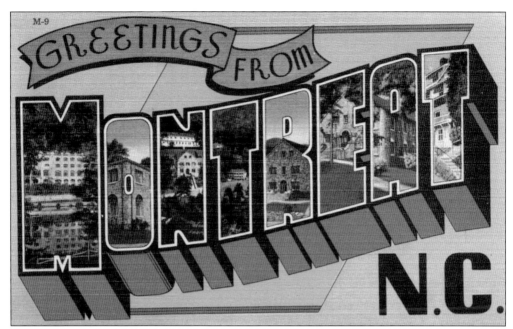

GREETINGS FROM MONTREAT. Montreat is an assembly grounds for the Presbyterian Church (USA) in Buncombe County. This linen-finish postcard dates from the early 1960s. It depicts eight buildings in Montreat, including Assembly Inn pictured in the "M." Assembly Inn was built in 1924 on the site of the old Montreat Hotel. It was rebuilt in 1940 after a fire.

ANDERSON AUDITORIUM AT MONTREAT. This glossy postcard was postmarked in 1965. Dr. Robert C. Anderson was elected president of the Montreat Retreat Association, owner of the assembly grounds, in 1911. His vision for the grounds played heavily in the development of the Montreat Conference Center of today. Anderson Auditorium was dedicated in 1922 and named for him.

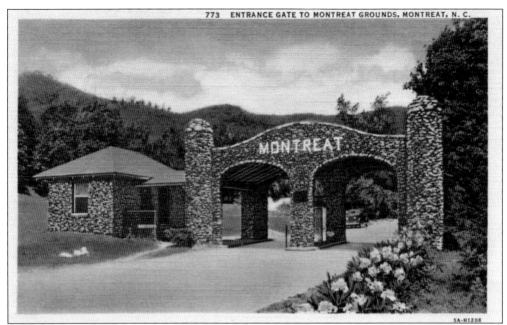

MONTREAT ENTRANCE GATE. The word Montreat came about by combining "mountain" and "retreat." This stone gate welcomes visitors to the retreat center and assembly grounds. A Connecticut Congregationalist minister purchased 4,500 acres here in 1897 for a Christian retreat, according to the Montreat Conference Center website. J.R. Howerton and the Presbyterian Synod of North Carolina purchased 4,000 acres of the original tract in 1905. This is a linen-finish postcard.

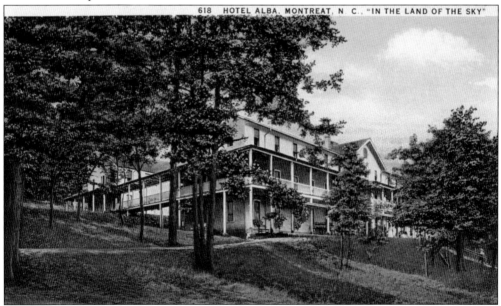

MONTREAT'S HOTEL ALBA. According to the website of the Town of Montreat, the Hotel Alba was destroyed by fire in 1945. Howerton Hall, named for J.R. Howerton, was built a few years later on the former site of Hotel Alba. Howerton Hall is a men's residence hall at Montreat College. This is a matte-finish postcard.

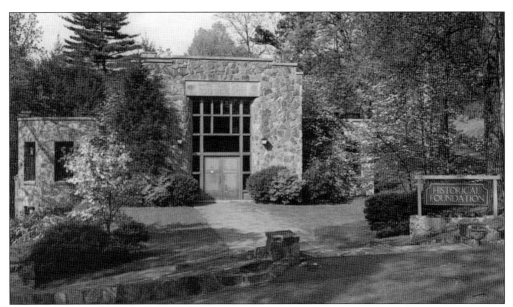

MONTREAT'S SPENCE HALL. This glossy postcard dates from about 1970 or 1980. The Historical Foundation of the Presbyterian Church in the United States, built Spence Hall to be used as a repository of historical documents and artifacts of the denomination and the Korean Presbyterian Church. It was named for Dr. Thomas Hugh Spence Jr., the longtime director of the foundation.

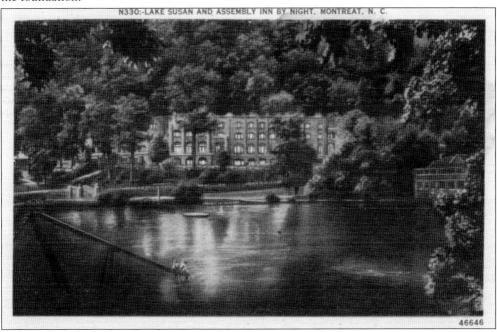

LAKE SUSAN AND ASSEMBLY INN. After housing 290 Japanese and German internees in 1942, Assembly Inn again became a lodge for people attending conferences at Montreat. Lake Susan was named for Susan Graham after she and her son donated money for the construction of the concrete dam in 1924. The original wooden dam that formed the lake was washed away in the flood of 1916. This is a linen-finish postcard.

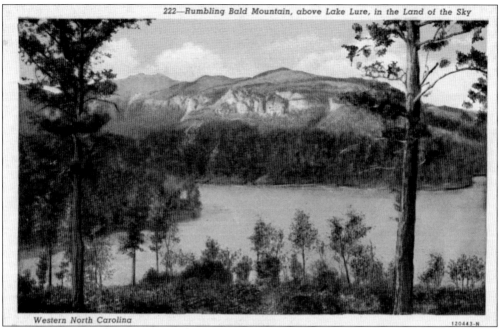

Western North Carolina

RUMBLING BALD MOUNTAIN. Rumbling Bald Mountain above Lake Lure takes its name from the rumbling sounds it made during a series of earthquakes that hit the area from 1874 to 1886. The "bald" portion of the mountain's name comes from the fact that it has many cliff faces. This postcard was postmarked in 1945.

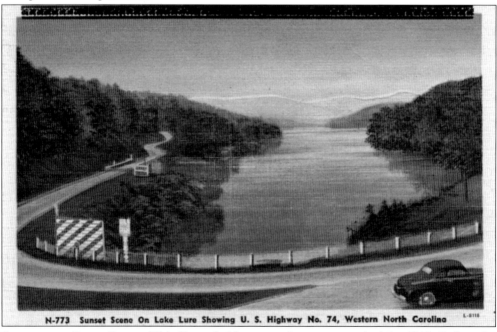

N-773 Sunset Scene On Lake Lure Showing U. S. Highway No. 74, Western North Carolina

SUNSET ON LAKE LURE. This linen-finish postcard was postmarked in 1949. Before the interstate highway system, two-lane US Highway 74 shown here was the main highway from Wilmington on the coast, to Charlotte in the Piedmont, and to Asheville in the Blue Ridge Mountains. Lake Lure covers 720 acres and has a 27-mile shoreline.

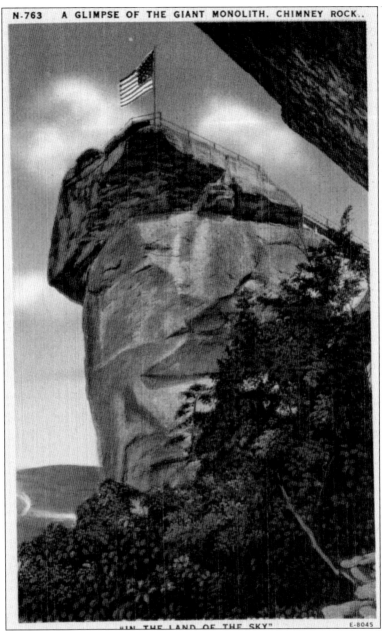

"IN THE LAND OF THE SKY" E-8045

CHIMNEY ROCK GIANT MONOLITH. This linen-finish color postcard was postmarked in 1951. Jerome B. Freeman purchased 400 acres in Rutherford County that included Chimney Rock around 1870 for $25. Dr. Lucius B. Morse, a physician in Missouri who contracted tuberculosis, came to North Carolina looking for a climate more conducive to healing his condition. He had a dream of developing the site containing Chimney Rock. He bought it and 64 surrounding acres from Freeman for $5,000 in 1902. It was operated for many years as a privately owned park. In 2007, the State of North Carolina and several partners purchased the park from the Morse family for $24 million and turned it into a state park. The view from atop the rock includes Hickory Nut Gorge, Lake Lure, and a glimpse into the Piedmont region of the state. More information is available at www.chimneyrockpark.com.

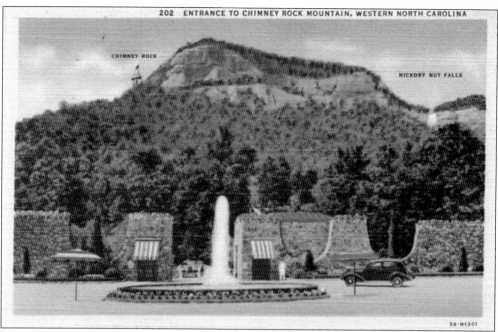

CHIMNEY ROCK ENTRANCE. The description on the back of the linen-finish postcard above, which was postmarked in 1941, states the following: "Massive walls, gardens, flower-topped pylons and fountain—all create an imposing gateway to the wonders of Chimney Rock." There are bright-red flowers all along the tops of the stone "pylons," and the awnings and beach umbrellas are topped in bright-red and green stripes. The glossy 1955 postcard below shows the chimney-like rock formation from which the Chimney Rock Park gets its name. The "chimney" can be seen here on the left side of the mountain, and Hickory Nut Falls is visible to the right of the mountain. When this postcard was made, Chimney Rock Park was privately owned.

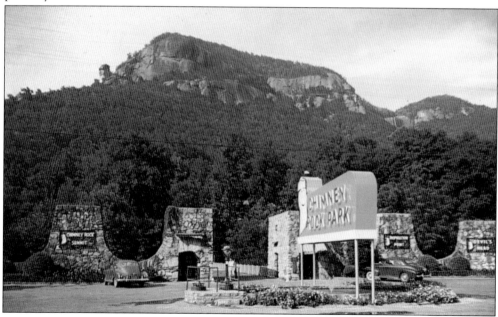

46

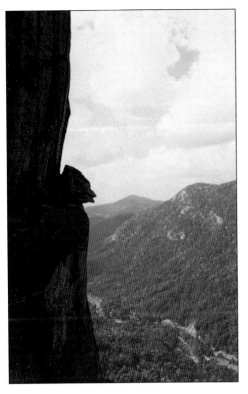

THE DEVIL'S HEAD. The photograph from which this postcard was made was taken in 1955. The glossy postcard probably dates from the 1960s. When a sheet of rock slid off the mountain, a piece of it landed on a ledge. Its original shape and erosion have resulted in a menacing face; hence the name Devil's Head. It sits above the chimney of Chimney Rock.

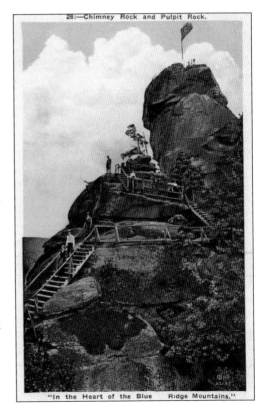

CHIMNEY ROCK AND PULPIT ROCK. Chimney Rock consists of Henderson Gneiss rock. It is located 25 miles southeast of Asheville in Rutherford County. Pulpit Rock is below the chimney-like rock formation and is accessible by 185 wooden steps in a joint in the granite between the Rock Pile and Pulpit Rock. Note the near-ankle length dresses the women in the photograph are wearing in this postcard from the early 1900s.

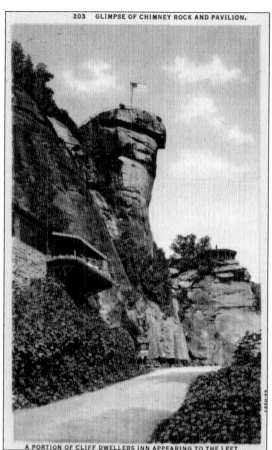

203 GLIMPSE OF CHIMNEY ROCK AND PAVILION,

A PORTION OF CLIFF DWELLERS INN APPEARING TO THE LEFT

PAVILION AND CLIFF DWELLERS INN. This linen-finish postcard was postmarked in 1950. It shows Pavilion Restaurant, which opened in 1919, to the left of the Chimney Rock. Cliff Dwellers Inn, on the left, was a one-story inn built into the side of the mountain. It opened for business in 1920 and closed when the elevator was installed inside the mountain in 1948.

HOT SPRINGS HOTEL. The Mountain Park Hotel and Spa is nestled in a valley along Spring Creek and the French Broad River in Hot Springs in Madison County. This postcard, postmarked in 1953, boasted of 52 rooms on the European plan. Generations have proclaimed the curative powers of the thermal waters of Hot Springs. The first organized golf club in the Southeastern United States was formed at Mountain Park Hotel.

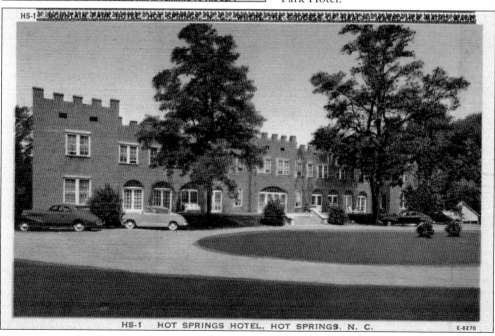

HS-1 HOT SPRINGS HOTEL, HOT SPRINGS, N. C. E-8270

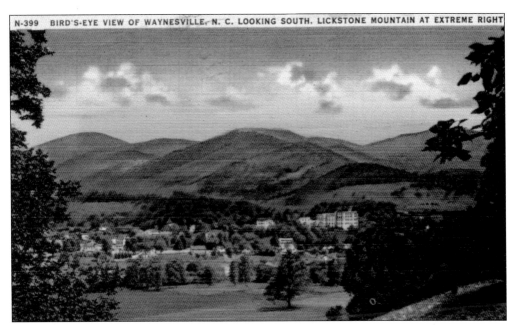

WAYNESVILLE AND LICKSTONE MOUNTAIN. Lickstone Bald, which is to the far right in this picture, is a mountain a little less than four miles from Waynesville, the county seat of Haywood County. The mountain's elevation is 5,679 feet. Waynesville's elevation is 2,752 feet. This linen-finish postcard was postmarked in 1946.

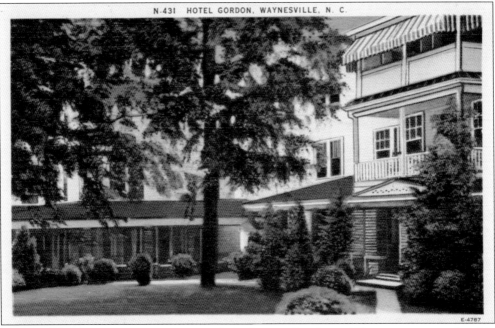

WAYNESVILLE'S HOTEL GORDON. Hotel Gordon was listed as a 150-person capacity hotel in a 1920s brochure compiled by the chamber of commerce in Waynesville. Daily rates were listed as $5 to $10 with weekly rates available. According to another 1920s brochure, the hotel was built in 1890 and enlarged in 1910. The Western Carolina University online digital collection includes these brochures. This is a linen-finish postcard.

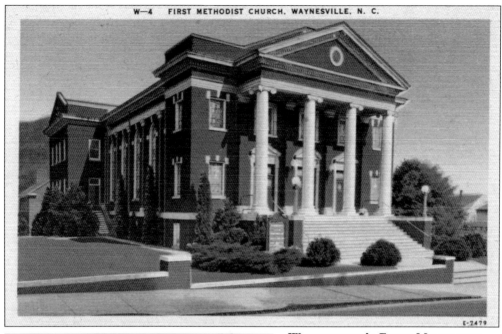

E-2479

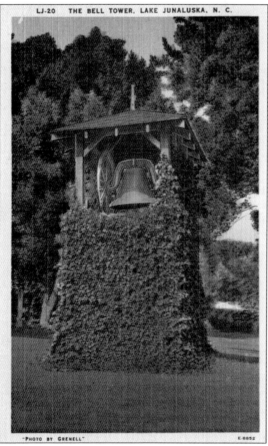

LJ-20 THE BELL TOWER, LAKE JUNALUSKA, N. C.

"PHOTO BY GRENELL" E-8852

WAYNESVILLE'S FIRST METHODIST CHURCH. The Methodist congregation of Waynesville was first mentioned in 1831 in the minutes of the Holston Conference of the Waynesville Circuit in the Asheville District of the Methodist Church. The sanctuary pictured here was completed in 1924 at a cost of $100,000, according to the church history by Eleanor Sloan. This is a linen-finish postcard.

LAKE JUNALUSKA BELL TOWER. The Bell Tower was constructed in 1920. C.E. Weatherby donated the bell to Lake Junaluska so it could be used to call conference attendees to meetings in the auditorium. It is located between the Harrell Center and Stuart Auditorium. This linen-finish postcard was postmarked in 1943.

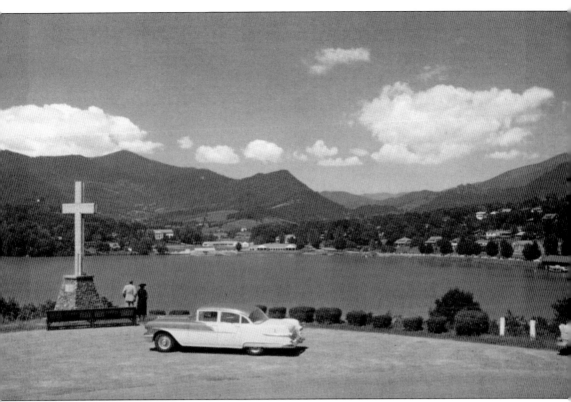

LAKE JUNALUSKA AND CROSS. When the Southern Assembly for the Methodist Church opened in Haywood County in 1913, Southern Railroad ran an excursion train from Asheville three times a day. By 1915, so many people were coming to the assembly grounds, not only for Methodist conferences, but also to enjoy the lake all summer, that Southern Railroad built a depot on the opposite side of the lake from Stuart Auditorium. The Southern Assembly was named for Chief Junaluska in 1929. Junaluska was chief of the Cherokee when the United States ordered the removal of the Cherokee people to Oklahoma Territory in 1838. Junaluska returned to North Carolina to serve as chief of the Cherokee who hid in the mountains and did not make the forced march west. Many Lake Junaluska postcards in the 1940s described the Methodist conference center as having "good water, electric lights and other public utilities, fine hotels, tennis, strong conference and chautauqua programs." This glossy postcard dates from the late 1950s.

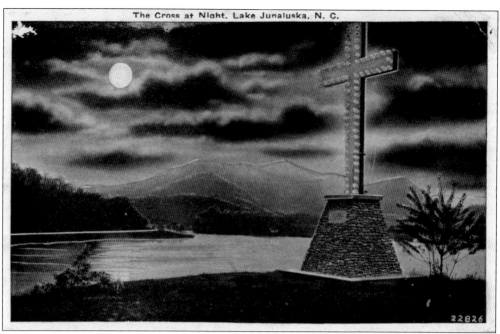

The Cross at Night, Lake Junaluska, N. C.

22826

CROSS AT LAKE JUNALUSKA. Built by the Federation of Wesley Bible Classes of the Western North Carolina Conference in 1922, the cross contains approximately 200 lightbulbs. It sits on a five-foot stone base and stands 25 feet high. The cross lights were turned off for a few nights in 1922, during World War II brownouts, and for repairs in 1994. This matte-finish postcard was postmarked in 1933.

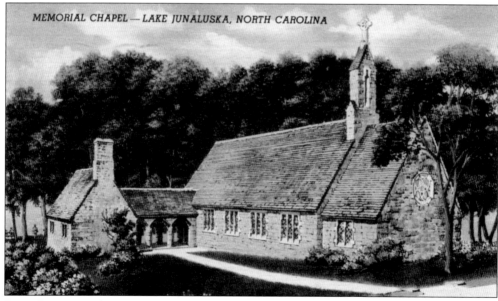

MEMORIAL CHAPEL — LAKE JUNALUSKA, NORTH CAROLINA

LAKE JUNALUSKA'S MEMORIAL CHAPEL. According to the Lake Junaluska Conference and Retreat Center website, Memorial Chapel was built in 1949 as a memorial to men and women who were affiliated with the Methodist Church, South, and served in the armed forces during World War II. The chapel is not a functioning church, so it does not have a pastor or regular services. This linen-finish postcard was postmarked in 1953.

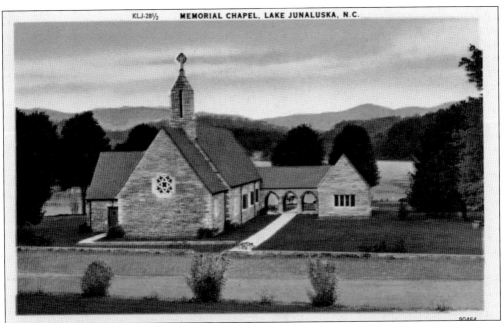

MEMORIAL CHAPEL AT LAKE JUNALUSKA. Howard Chandler Christy's painting *The Great Commission* was moved from Memorial Chapel's Room of Memory to the main lobby of the new Terrace Hotel at Lake Junaluska because Memorial Chapel is not heated or air-conditioned. It was feared the painting would deteriorate if left in Memorial Chapel. This is a glossy postcard.

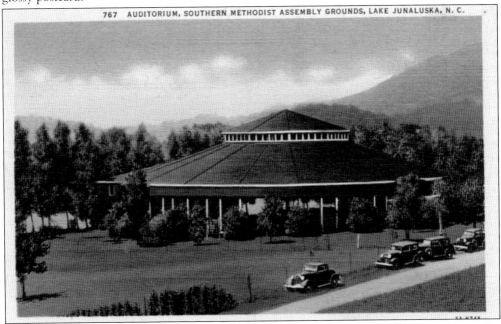

STUART AUDITORIUM. Named for George R. Stuart, who dreamed of establishing a Methodist assembly grounds, Stuart Auditorium was the first building completed at Lake Junaluska. A dirt-floor open-air structure in the beginning, the auditorium now has theater seating and can accommodate 2,000 people. This linen-finish postcard was postmarked in 1941.

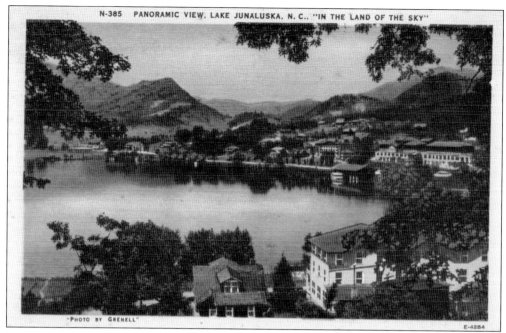

"PHOTO BY GRENELL"

E-4284

PANORAMIC VIEW OF LAKE JUNALUSKA. In the 1940s, as home of the Southern Assembly of the Methodist denomination, Lake Junaluska was billed as "The Summer Capital of Southern Methodism." The lake at Lake Junaluska originally covered 252 acres, but subsequent expansion of roads, parking lots, and buildings has decreased it by about 50 acres. This linen–finish postcard was postmarked in 1953.

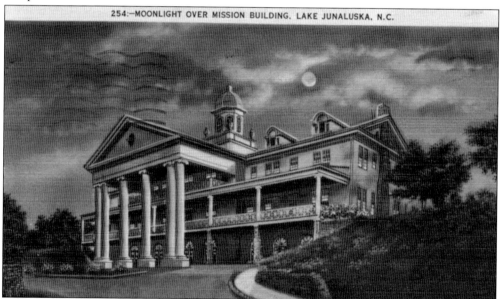

MISSION BUILDING IN MOONLIGHT. Originally called the Centenary Mission Inn, this building was renamed the Lambuth Inn in honor of Walter R. Lambuth, a beloved missionary. The inn was remodeled in 1956, and the west wing was annexed to accommodate the Ninth World Methodist Conference. The east wing was completed in 1964. This linen–finish postcard was postmarked in 1943.

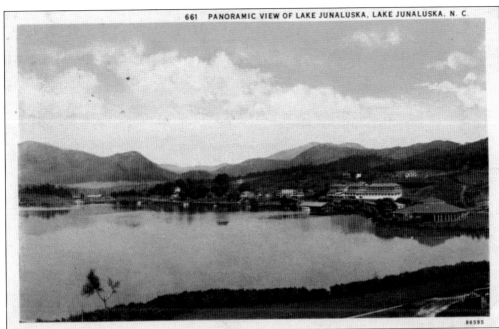

THE LAKE CALLED JUNALUSKA. The lake at the Lake Junaluska Conference and Retreat Center was created as a result of the damming of Richland Creek in 1911. The construction of the dam took two years. The lake provides a place for swimming as well as an excursion boat. In the 1940s, as home of the Southern Assembly of the Methodist denomination, Lake Junaluska was billed as "The Summer Capital of Southern Methodism." The matte-finish postcard above was postmarked in 1932. It clearly shows Stuart Auditorium on the right and the Terrace Hotel to the left of the auditorium. To the left of the hotel is Cherokee Inn. The matte-finish postcard below was postmarked in 1939.

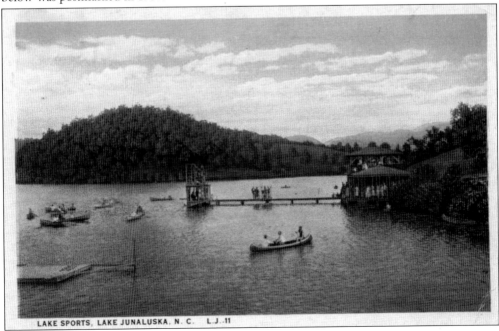

LAKE SPORTS, LAKE JUNALUSKA, N. C. L.J.-11

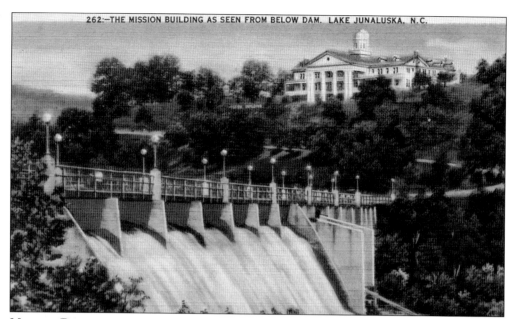

MISSION BUILDING FROM BELOW DAM. The dam that created Lake Junaluska was completed in 1913. The dam was used to generate power for the electric lights in Stuart Auditorium during the assembly later that year. The dam generated electricity for only a few years because it was unable to produce enough energy to meet the needs of the assembly grounds. This linen-finish postcard was postmarked in 1936.

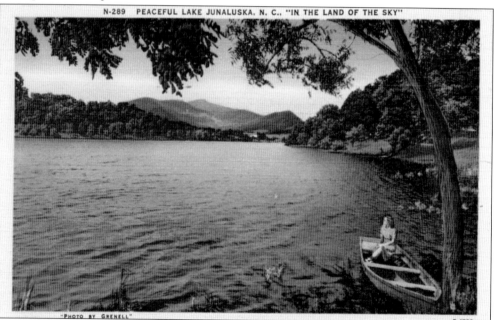

N-289 PEACEFUL LAKE JUNALUSKA, N. C., "IN THE LAND OF THE SKY"

"PHOTO BY GRENELL"

PEACEFUL LAKE JUNALUSKA. This linen-finish postcard of Lake Junaluska probably dates from the 1930s or 1940s. The beauty of Lake Junaluska attracted Hollywood's attention in 1956. The Southern Railroad depot, which had closed in 1948, was used in a scene in the Sir Alec Guinness and Grace Kelly movie *The Swan*. The depot has since been sold and moved. It is now a private residence.

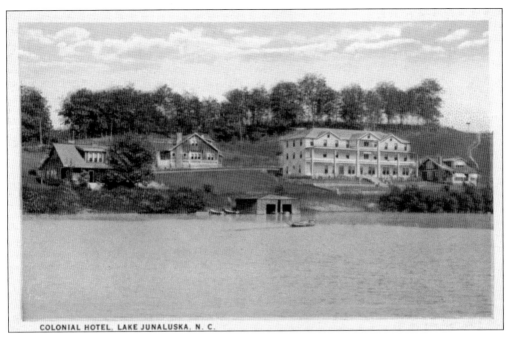

COLONIAL HOTEL, LAKE JUNALUSKA, N. C.

COLONIAL HOTEL, LAKE JUNALUSKA. The Colonial Hotel was built in 1922. It was privately owned and operated when it opened for business that year. It housed the Snyder School for Boys part of the year and housed people attending conferences at Lake Junaluska in the summer. The hotel was bought by Mr. and Mrs. George Finch and donated to the Lake Junaluska Conference and Retreat Center in 1971. It provided lodging for the center's guests until it was renovated in 1989. Since that time, it has housed the center's summer staff. The matte-finish postcard above was postmarked in 1948. The postcard below has a linen finish.

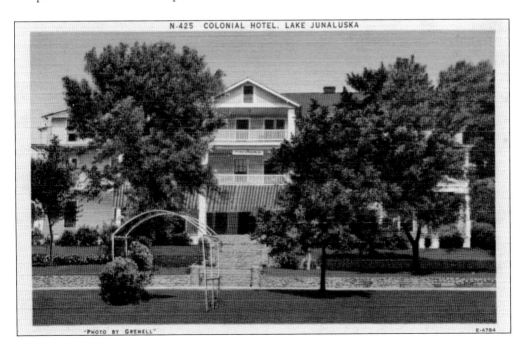

N-425 COLONIAL HOTEL, LAKE JUNALUSKA

"PHOTO BY GRENELL" E-4784

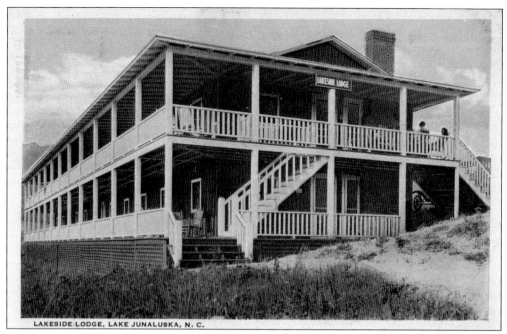

LAKESIDE LODGE. J.B. Ivey built two structures to be the Lakeside Lodge between 1921 and 1922 at Lake Junaluska. The buildings shared a kitchen and dining area. The Lake Junaluska Assembly purchased the lodge in 1973 and demolished one of the buildings. The remaining structure was torn down in 1985 to make room for a new Lakeside Lodge. Intended for summer staff, in 1989 it began housing visitors. This postcard was postmarked in 1942.

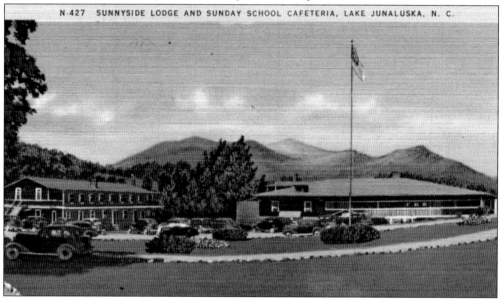

SUNNYSIDE LODGE AND CAFETERIA. This postcard, postmarked in 1950, shows the original Sunnyside Lodge and the Sunday School Cafeteria at Lake Junaluska. The Sunday School Cafeteria is now known as the Jones Dining Hall. The original Sunnyside Lodge was also known as Whitfield Lodge. A new Sunnyside Lodge replaced it in 1958. Materials from the old building were used to construct homes.

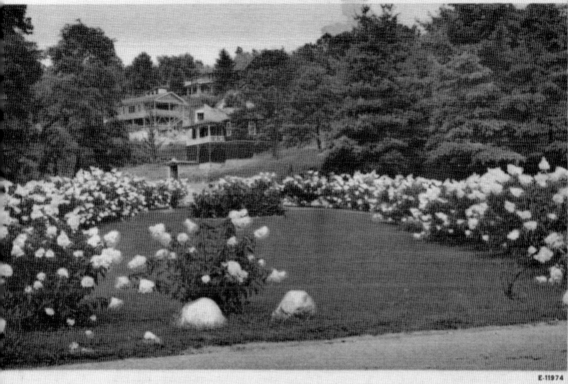

E-11974

HYDRANGEAS ON LAKE SHORE DRIVE. This linen-finish postcard from Lake Junaluska was postmarked in 1953. Hydrangeas are ornamental plants that produce large flower heads from spring until late autumn. The color of hydrangea blossoms is determined by soil acidity and can range from pink to blue to purple in this region. North Lakeshore Drive and South Lakeshore Drive encircle the lake at Lake Junaluska except for the portion of the lake next to US Highway 19. In the 1960s, Dr. Lee Tuttle planted roses along a portion of Lakeshore Drive across from the World Methodist Building, according to the Lake Junaluska "Walking Trail Guide" by Stephanie Drum. (It can be found online through the Lake Junaluska Conference and Retreat Center's website.) Whether with hydrangeas, roses, or other flowers, Lakeshore Drive continues to be beautified with a variety of flowers and landscaping.

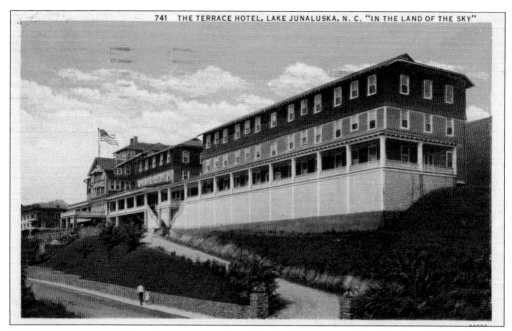

TERRACE HOTEL AT LAKE JUNALUSKA. Lake Junaluska's Terrace Hotel had a rocky beginning. In the 1910s, Dr. Rhodes, a college professor, set out to build a hotel called College Inn. He ran into financial problems, though. After the Junaluska Inn burned in 1918, the Junaluska Hotel Company bought the unfinished College Inn. It was completed in 1920 and was called Terrace Hotel. This linen-finish postcard was postmarked in 1944.

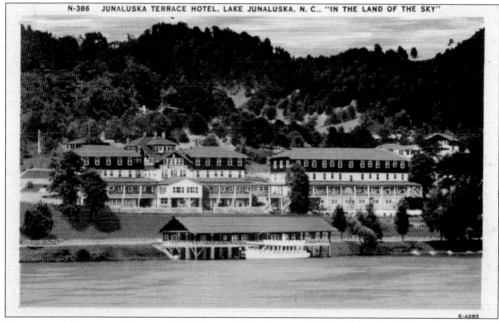

JUNALUSKA TERRACE HOTEL. The Terrace Hotel opened for business in 1920 and stood until the 1960s. A new Terrace Hotel was built overlooking the lake in 1977. From rooms in the new hotel, guests can enjoy views of the lighted cross across the lake at night. This is a linen-finish postcard.

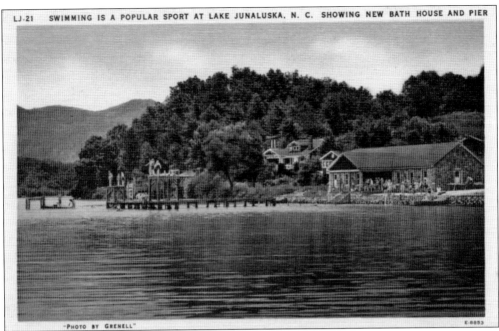

"PHOTO BY GRENELL" E-8853

SWIMMING AT LAKE JUNALUSKA. This linen-finish postcard was postmarked in either 1953 or 1958. (The last digit is unclear due to handwriting under it.) It shows the "new bath house and pier." The pier included two diving platforms, and another diving platform can be seen in the lake. Today, the Lake Junaluska Retreat and Conference Center has a pool.

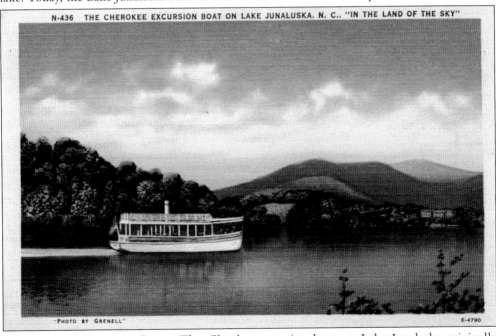

N-436 THE CHEROKEE EXCURSION BOAT ON LAKE JUNALUSKA. N. C.. "IN THE LAND OF THE SKY"

"PHOTO BY GRENELL" E-4790

CHEROKEE EXCURSION BOAT. The *Cherokee* excursion boat on Lake Junaluska originally ferried guests from the train depot side of the lake to the Stuart Auditorium side of the lake. That was *Cherokee I.* Now the *Cherokee IV* takes guests on guided lake cruises on summer evenings. This linen-finish postcard has a 1949 postmark.

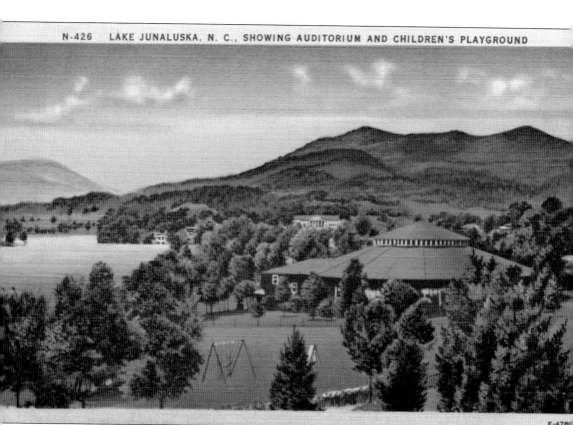

E-478C

STUART AUDITORIUM AND CHILDREN'S PLAYGROUND. Stuart Auditorium and the J.B. Ivey Playground are pictured in this linen-finish postcard that was postmarked in 1943. This shows the playground at its original location, where Memorial Chapel now stands. Joseph Benjamin Ivey founded J.B. Ivey and Sons, a department store in Charlotte. A devout Methodist, Ivey required the display windows in his department store to be covered on Sundays so residents would not be tempted to window shop on the Sabbath. He created the playground in the early days of Lake Junaluska Assembly. It is said that he visited the playground regularly, giving birthday parties to the children and telling them stories. The playground was moved from the location pictured here in 1946 to the Paul Kern Youth Center's present location. In 1995, it was moved to land adjacent to the Wilson Children's Complex.

Three

GREAT BALSAMS AND PLOTT BALSAMS

The Great Balsams and Plott Balsams are found in Jackson and Haywood Counties, and so portions of those counties are included in this chapter.

The Great Balsam Mountains are a subrange of the Blue Ridge Mountains. The Blue Ridge Parkway runs along the Great Balsams and reaches its highest point (6,053 feet) at Richland Balsam at milepost 431. Richland Balsam's elevation is 6,410 feet. The parkway connects the Soco Gap at the southeast corner of the Qualla Boundary with the Balsam Gap, which is a pass between the Great Balsams and the Plott Balsams.

Landmarks in the Great Balsam Mountains include the Devil's Courthouse, Balsam Gap, Tanasee Bald, and Judaculla Rock.

The Plott Balsams are another subrange of the Blue Ridge Mountains. The Plott Balsams run from Sylva in Jackson County to Maggie Valley in Haywood County. Five mountain peaks in the Plott Balsams exceed 6,000 feet in elevation. Much of the range is protected as part of the Nantahala National Forest.

The Plott Balsam Mountains are named for the pioneer family by that name. Johannes Plott came to North Carolina from Germany in the late 1700s and settled at the foot of the range. He developed the Plott Hound hunting dog breed after settling here. The Plott Hound is the official state dog of North Carolina.

BEAUTIFUL MAGGIE VALLEY. This glossy postcard, which probably dates from the 1970s, depicts Maggie Valley as it is seen from US Highway 19 near Soco Gap. Maggie Valley is in Haywood County. Soco Gap is at the uppermost point of Maggie Valley. The http://MaggieValley.org/history.php website tells the interesting story of how Maggie Valley got its name in 1904. Patty Pylant Kosier wrote *Maggie of Maggie Valley* about her mother, Maggie Mae Setzer Pylant. When Maggie was 10 years old in 1900, her father wanted to establish a post office. He applied to the US Post Office and submitted three names for consideration for his post office. Those three names were already in use in North Carolina. He then submitted the names of his three daughters, Cora, Mettie, and Maggie Mae, along with Jonathan Creek. The US postmaster general chose Maggie as the name, which embarrassed little Maggie Mae.

GHOST MOUNTAIN INCLINE RAILWAY. Ghost Town in the Sky is a family amusement park on Buck Mountain in Maggie Valley. The park first opened in 1961, according to the park's website. An incline railway transports visitors to Ghost Town at an elevation of 3,300 feet. This glossy postcard was postmarked in 1963.

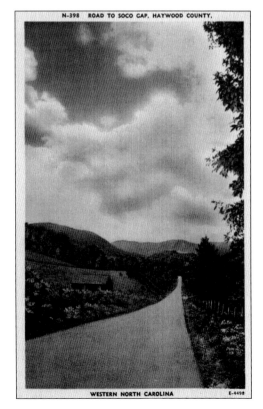

N-398 ROAD TO SOCO GAP, HAYWOOD COUNTY,

WESTERN NORTH CAROLINA E-4498

ROAD TO SOCO GAP. Soco Gap in Haywood County is one of four depressions in the balsam range, according to a study of the Davey Farm there by Barry M. Buxton, which can be found at the National Park Service website. The Cherokee called the gap Ahaluna, due to a fierce battle there with the Shawnee; the name translates to "ambush place." This is a linen-finish postcard.

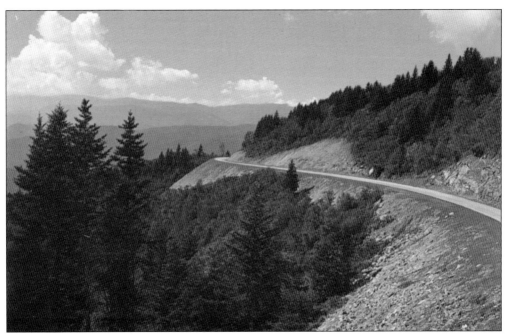

BLUE RIDGE PARKWAY ON WATERROCK KNOB. Waterrock Knob is a 6,292-foot mountain in Haywood and Jackson Counties. It is said that the mountain takes its name from the fact there is a cool stream there where farmers and hunters knew they could get a refreshing drink of cold water. This is a glossy postcard.

FLAME AZALEA. *Rhododendron calendulaceum*, also known as the flame azalea, grows in the Appalachian Mountains from New York to Georgia. The flowers range in color from yellow to orange to red. The shrub blooms in late May and June in the mountains of North Carolina. This linen-finish postcard was postmarked in 1954.

Mountain Rhododendron in Bloom.
This is a matte-finish postcard. This hardy plant survives the high winds and temperatures well below zero in the winter and then blooms in the summer. The leathery, dark-green leaves of this evergreen plant droop and curl up in extremely cold temperatures. Rhododendrons grow in profusion in the Blue Ridge Mountains.

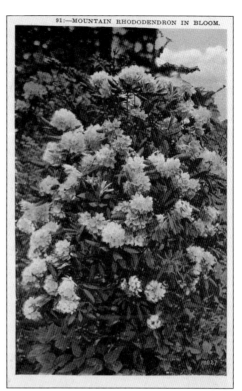

A Valley along Blue Ridge Parkway. Many beautiful valleys like this one can be found along the Blue Ridge Parkway in the Great Balsams and Plott Balsams of North Carolina. The parkway has more than 200 overlooks that provide opportunities for motorists to pull off the scenic highway, relax, picnic, take photographs, paint a picture, and enjoy the miles of scenery. Many overlooks have informational exhibits.

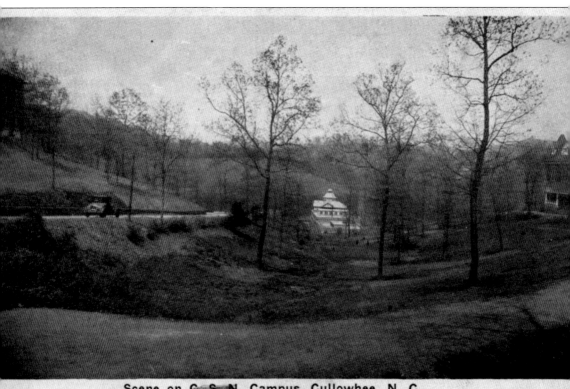

Scene on C. S. N. Campus, Cullowhee, N. C.
W.C.T.C.

WESTERN CAROLINA TEACHERS COLLEGE. This black-and-white matte-finish postcard was postmarked in 1931. The sender corrected the title "Scene on C.S.N. Campus, Cullowhee, N.C." to read, "W.C.T.C. Campus." That indicates the card was manufactured when the present-day Western Carolina University was called Cullowhee State Normal, which was from 1925 to 1929. According to the www.wcu.edu website, the university was founded as a semipublic secondary school in 1889. Two years later, it was chartered as Cullowhee High School. The early mission of the school was to train teachers for Western North Carolina. The state legislature designated it as the first publicly funded normal school in 1893. It grew into a junior college, and in 1929, it was chartered as a four-year institution with the name Western Carolina Teachers College. The demand for the liberal arts resulted in an ever-expanding curriculum. The name was changed to Western Carolina College in 1953 and to Western Carolina University in 1967. It became a member of the University of North Carolina system in 1972. Cullowhee is in Jackson County.

Four

GREAT SMOKY MOUNTAINS NATIONAL PARK AND QUALLA BOUNDARY

Great Smoky Mountains National Park is located in Swain and Haywood Counties in North Carolina and Blount, Sevier, and Cocke Counties in Tennessee. The terrain, climate, range in elevation, precipitation, tree cover, and remoteness of the park result in a place of amazing variety in flora and fauna.

The Great Smoky Mountains lay in the middle of the Cherokee Indians' territory in the mid-1600s when Spanish explorer Hernando de Soto arrived. In the 1820s, a Cherokee by the name of Sequoyah invented the Cherokee syllabary, making the Cherokee one of the first American Indian tribes to have a written language.

Descendants of the Cherokee Indians who hid out in the mountains to avoid the 1838 forced march to Oklahoma known as the Trail of Tears live on a land trust called the Qualla Boundary. The main part of the Qualla Boundary includes portions of Jackson, Swain, and Haywood Counties, with noncontiguous portions in Cherokee and Graham Counties.

According to the website of the Cherokee Museum, "The legal name for the Cherokee people in North Carolina is: 'The Eastern Band of Cherokee Indians.' Because 'Native American' can refer to anyone born in America, the North American Indian Women's Association recommends using the term 'American Indians.' " Therefore, the terms "Cherokee Indian" and "American Indian" are used in this book.

Some of the best trout fishing in the Eastern United States is found in the Oconaluftee River tributaries within the Qualla Boundary. The name *Oconaluftee* comes from the Cherokee word *egwanulti*. It means "by the river" and refers to one of the oldest Cherokee villages that was along that river.

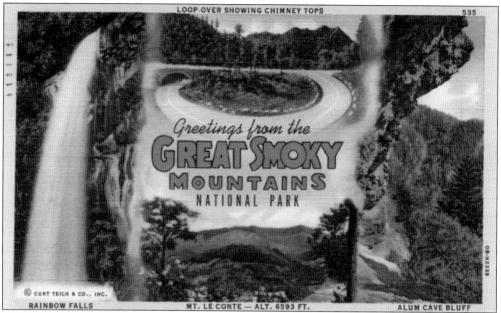

GREETINGS FROM THE SMOKIES. This linen-finish postcard was postmarked in 1943 and depicts several scenes in Great Smoky Mountains National Park. The Loop is where Newfound Gap Road crosses over itself. Chimney Tops is a double-peaked mountain. Alum Cave Bluff is a 100-foot-high cliff (not a cave) containing alum deposits near Mount Le Conte. The 80-foot Rainbow Falls is a waterfall near Cherokee Orchard, out from Gatlinburg, Tennessee.

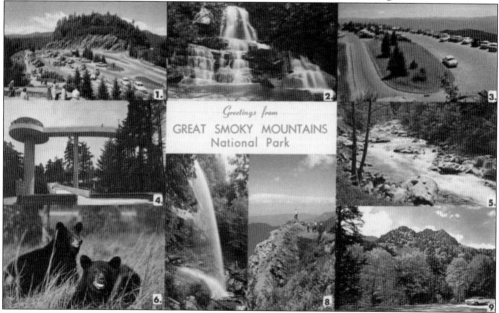

GREETINGS FROM GREAT SMOKY MOUNTAINS NATIONAL PARK. This glossy postcard features nine numbered scenes identified on the back as follows: Newfound Gap parking area, Laurel Falls, Parking Area for Clingmans Dome, Clingmans Dome Tower, Little River, black bears, Rainbow Falls, hikers at Charlies Bunion, and the Chimney Tops in autumn. This glossy postcard was postmarked in 1965.

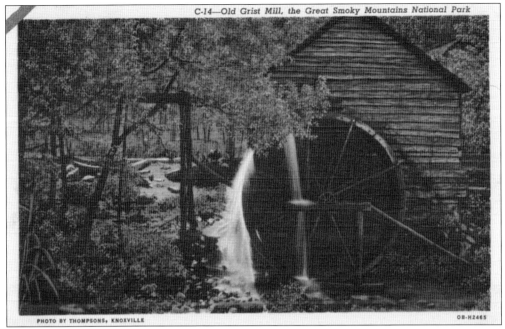

PHOTO BY THOMPSONS, KNOXVILLE OB-H2465

OLD GRISTMILL IN THE SMOKIES. Into the 20th century, some mountaineers still used waterwheel-driven gristmills to grind their corn. Corn was ground into grits and cornmeal. The supports for the millrace or flume are visible to the left of the water wheel in this postcard. The water hitting the water wheel causes it to turn and provide the power to grind the corn.

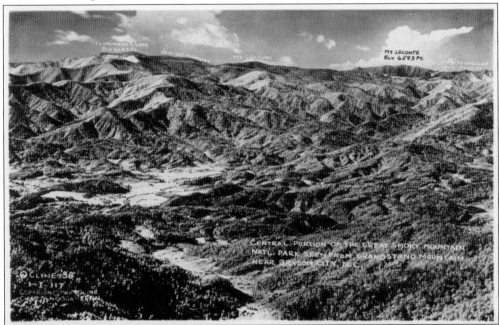

CENTRAL GREAT SMOKY MOUNTAINS NATIONAL PARK. This is a black–and–white real-photo postcard made in 1936. This was the view as seen from Grandstand Mountain near Bryson City in Swain County. It sits just a few miles from the Qualla Boundary and even closer to Great Smoky Mountains National Park.

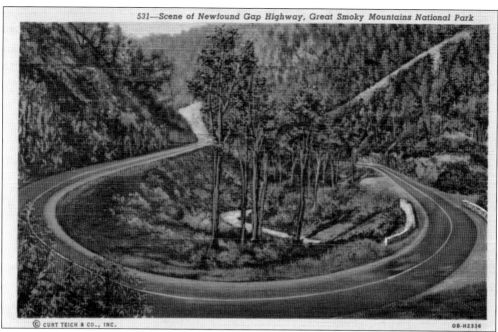

SCENE OF NEWFOUND GAP ROAD. This is a linen-finish postcard. Black bear sightings in Great Smoky Mountains National Park are less frequent than a few decades ago when it was not unusual for traffic to come to a standstill on Newfound Gap Road to allow one or two bears to cross the highway.

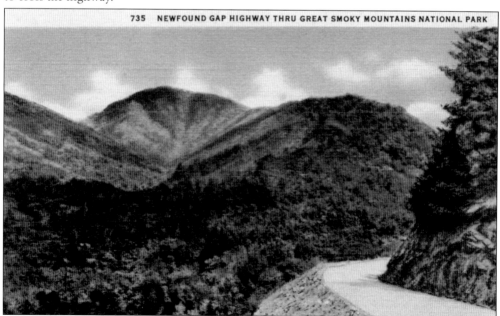

NEWFOUND GAP ROAD. This linen-finish postcard was written in 1939. Note how narrow the highway in Great Smoky Mountains National Park looks, and there is no guardrail! A gap is a low point in an Appalachian mountain ridge. Gaps are called notches or passes in other parts of the United States. The Newfound Gap was discovered in 1872, more than a mile from Indian Gap.

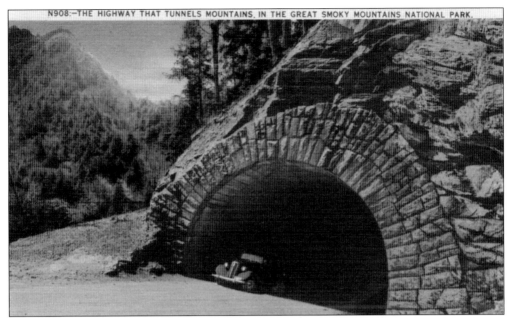

THE HIGHWAY THAT TUNNELS MOUNTAINS. The description on the back of this linen-finish postcard from Great Smoky Mountains National Park reads, "There are many spectacular views and engineering features along the Tennessee side of the Newfound Gap Road. Here we see the upper end of the lower tunnel, with the Chimney Tops rising majestically in the left background."

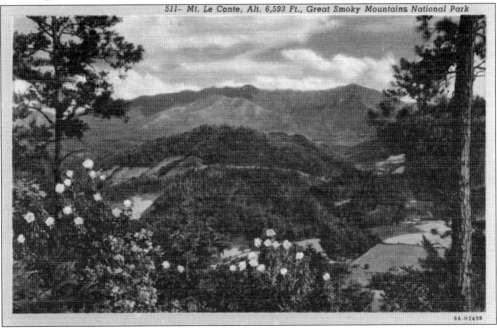

511- Mt. Le Conte, Alt. 6,593 Ft., Great Smoky Mountains National Park

MOUNT LE CONTE. Although Clingmans Dome is the highest peak in Great Smoky Mountains National Park at an elevation of 6,643 feet, Mount Le Conte is the tallest mountain from base to summit in the Great Smoky Mountains. With an elevation of 6,593 feet, it rises 5,301 feet from its base to its peak. This linen-finish postcard probably dates from the 1930s.

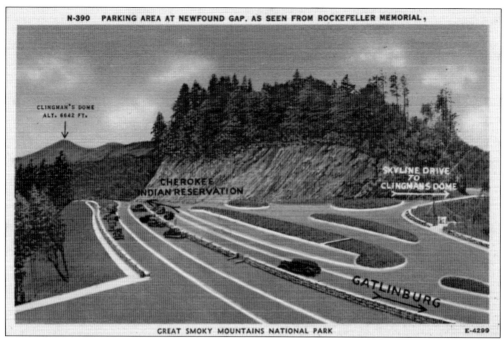

CLINGMAN'S DOME
ALT. 6642 FT.

CHEROKEE
INDIAN RESERVATION

SKYLINE DRIVE
TO
CLINGMANS DOME

GATLINBURG

GREAT SMOKY MOUNTAINS NATIONAL PARK E-4299

NEWFOUND GAP PARKING LOT. A new passageway was discovered in the 1850s that provided a shorter route than Indian Gap through the central Smoky Mountains. To this day, it is known as Newfound Gap, and US Highway 441 through Great Smoky Mountains National Park is called Newfound Gap Road. Both postcards on this page are of a linen finish. The postcard above shows the view from the Laura Spelman Rockefeller Memorial. It also identifies Clingmans Dome in the distance and indicates in which direction Cherokee and Gatlinburg lie, as well as the road from the parking area to Clingmans Dome. The postcard below shows the Rockefeller Memorial.

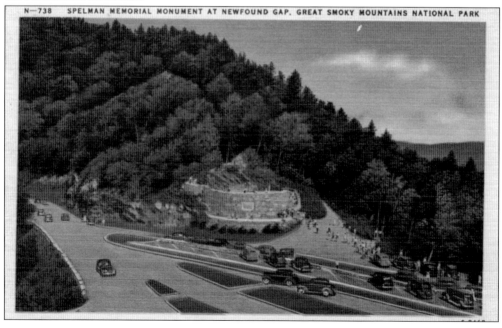

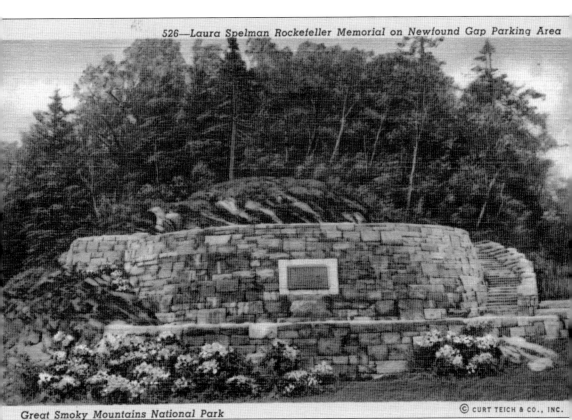

Great Smoky Mountains National Park © CURT TEICH & CO., INC.

LAURA SPELMAN ROCKEFELLER MEMORIAL. Laura Spelman Rockefeller was the mother of John D. Rockefeller Jr. A grassroots effort to raise $10 million to save the Great Smokies from logging in the 1920s was coming up short, but in 1927, Rockefeller was so moved by George Masa's photographs of the mountains and the stories of the logging of old-growth forests that he donated, from the Laura Spelman Rockefeller Fund, the remaining $5 million that was needed to save the Smoky Mountains. Logging continued, and the fulfillment of pledges slowed during the Great Depression. Pres. Franklin D. Roosevelt set a precedent when he allocated $1.5 million in federal funds to purchase the last of the land for Great Smoky Mountains National Park. Pres. Franklin D. Roosevelt dedicated the park from the Laura Spelman Rockefeller Memorial in 1940. This is a linen-finish postcard.

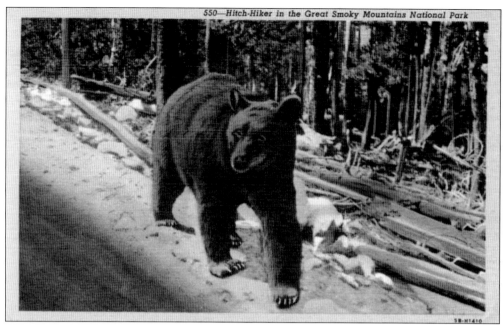

BLACK BEAR IN THE PARK. Black bears in the Great Smoky Mountains can be six feet long and three feet high at the shoulder. A typical male weighs about 250 pounds in the summer, and females weigh half that, but bears weighing 600 pounds have been documented. They can run 30 to 35 miles per hour. This linen-finish postcard was postmarked in 1955.

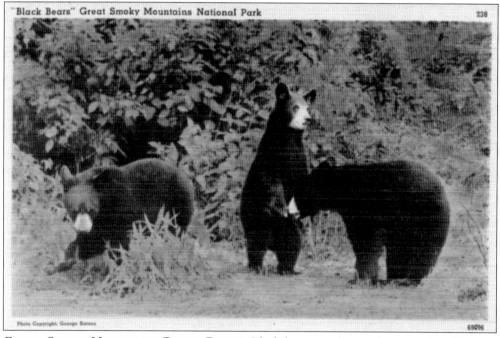

"Black Bears" Great Smoky Mountains National Park 238

GREAT SMOKY MOUNTAINS BLACK BEARS. Black bears can live to be more than 25 years old in the wild. They have color vision and a keen sense of smell that helps them find carrion upon which to feed. It is illegal to willfully get within 150 feet of a black bear in Great Smoky Mountains National Park. This linen-finish postcard was postmarked in 1949.

A Big Black Bear. This linen-finish postcard of a black bear in Great Smoky Mountains National Park was postmarked in 1948. Black bears feed mostly on berries, nuts, grasses, dead or decaying animals, and insect larvae. Feeding bears is dangerous to humans and decreases a bear's life expectancy by half.

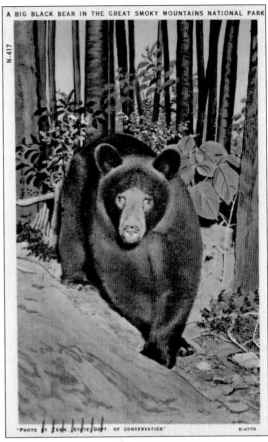

A BIG BLACK BEAR IN THE GREAT SMOKY MOUNTAINS NATIONAL PARK

"PHOTO BY TENN. STATE DEPT. OF CONSERVATION"

Newfound Gap Road from Chimney Tops. This glossy black-and-white real-photo postcard was made in 1936. The aerial view gives a glimpse of a portion of the winding Newfound Gap Road that is in the valley between surrounding mountains. In its 32-mile length, the road between Cherokee, North Carolina, and Gatlinburg, Tennessee, climbs approximately 3,000 feet.

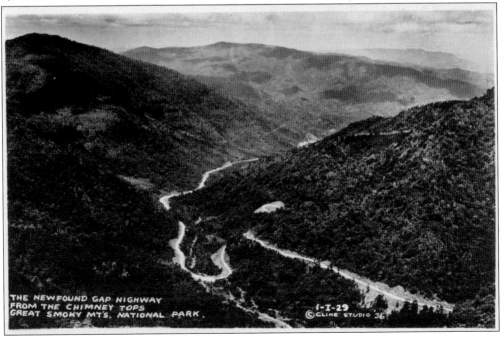

THE NEWFOUND GAP HIGHWAY FROM THE CHIMNEY TOPS GREAT SMOKY MTS. NATIONAL PARK. 1-I-29 ©CLINE STUDIO 36

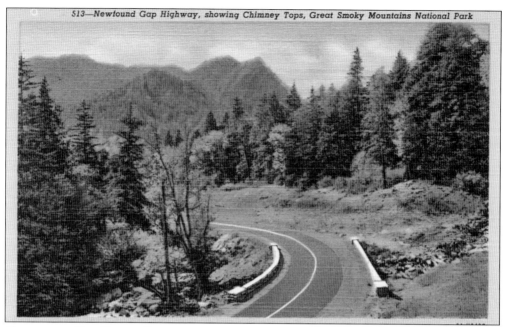

513—Newfound Gap Highway, showing Chimney Tops, Great Smoky Mountains National Park

NEWFOUND GAP ROAD, SHOWING CHIMNEY TOPS. This is a linen-finish postcard. A two-mile hiking trail leads from a parking area on Newfound Gap Road to Chimney Tops. Though not for the faint of heart, the trail offers breathtaking views of the Great Smoky Mountains with a wonderful array of wildflowers and some old-growth trees along the way.

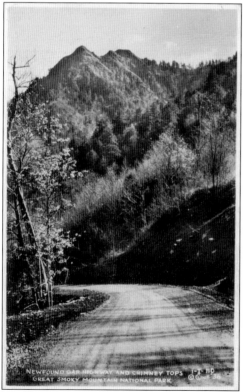

NEWFOUND GAP ROAD AND CHIMNEY TOPS. This is a glossy black-and-white real-photo postcard from 1936. This wonderful photograph plainly shows that this section of Newfound Gap Road was not paved at that time. It was all paved before Great Smoky Mountains National Park was opened to the public in 1938.

CHIMNEY TOPS IN THE SMOKIES. Chimney Tops is a double-peak mountain above the head of Deep Creek in the Swain County, North Carolina, portion of Great Smoky Mountains National Park. It was called Duni'skwa lgun'i by the Cherokee Indians. The name means "forked antler," but more specifically, it means the antler is attached, as if the deer is concealed below. This is a linen-finish postcard.

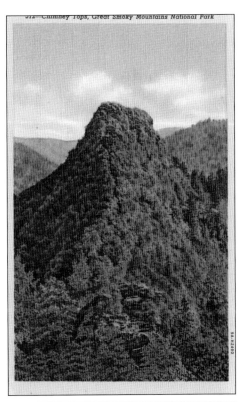

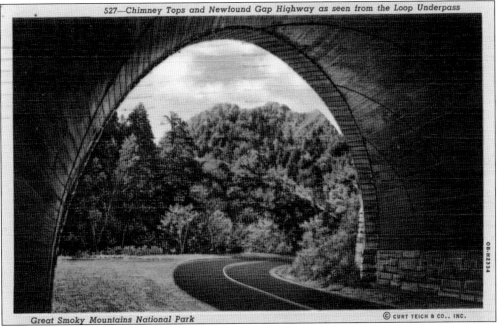

CHIMNEY TOPS FROM THE LOOP UNDERPASS. This linen-finish postcard was postmarked in 1945. This postcard gives a unique split-second view of Chimney Tops from inside the Loop on Newfound Gap Road in Great Smoky Mountains National Park in the fall of the year when deciduous trees in the park turn a brilliant range of color.

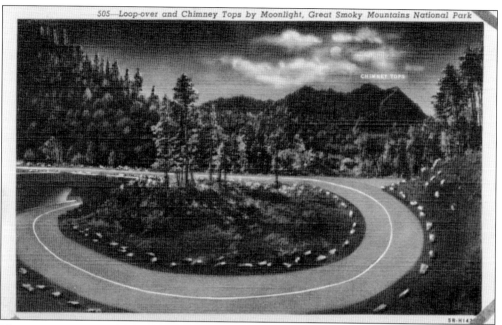

THE LOOP-OVER ON NEWFOUND GAP ROAD. This linen-finish postcard probably dates from the 1930s. Newfound Gap Road in Great Smoky Mountains National Park tunnels under itself, forming a helix. The design replaced two dangerous switchbacks on the old Tennessee Highway 71, which was built in the 1920s. Today the road is US Highway 441.

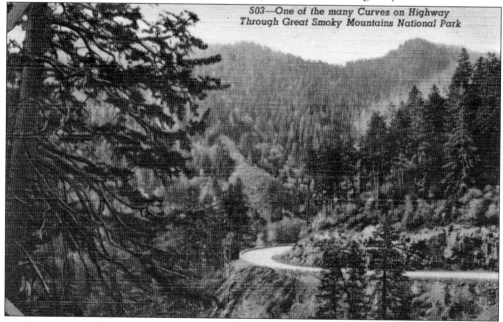

A CURVE ON NEWFOUND GAP ROAD. This view shows how beautiful Great Smoky Mountains National Park was when it opened and before much of the forest was ravaged by the balsam woolly adelgid. According to the National Park Service, "The adelgid was introduced on trees imported from Europe, and the fir has little natural defense against it." This linen-finish postcard probably dates from the 1930s before vegetation covered the roadside.

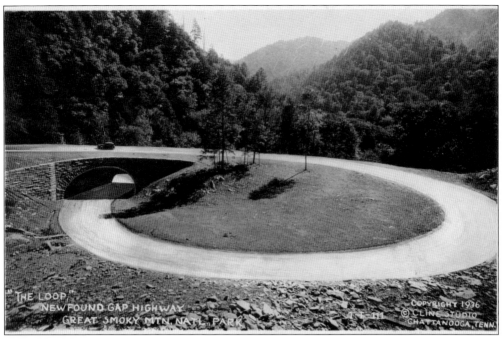

THE LOOP IN THE GREAT SMOKIES. These black-and-white glossy real-photo postcards were made in 1936. The Great Smoky Mountains National Park Roads & Bridges portion of the Historic American Engineering Record of the National Park Service gives many details about the Loop. Probably designed by Charles Peterson, the Loop was constructed in 1935 by C.Y. Thomason Company of Greenwood, South Carolina, at a cost of $77,644. Stone quarried nearby and reinforced concrete were used in the construction of the bridge portion, which is 95 feet long, 42 feet wide, and 21 feet high in the center of the arch.

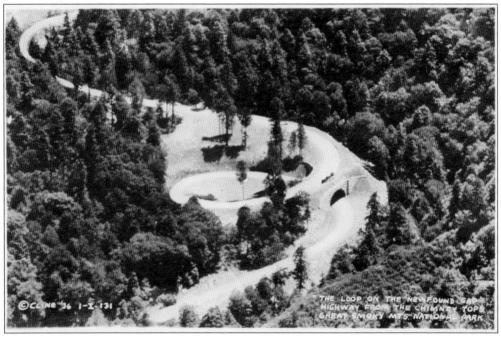

46710

SKYLINE DRIVE NEAR CLINGMANS DOME. Clingmans Dome was named for Thomas Lanier Clingman, who first accurately measured the mountain's elevation. The mountain is on the border of North Carolina and Tennessee in Great Smoky Mountains National Park and is considered to be the highest peak in Tennessee. Clingman, a lawyer and politician by trade, thought the mountain that eventually took his name was the highest peak in the Black Mountains. His former teacher at the University of North Carolina, Elisha Mitchell, maintained that Mount Mitchell was the highest. Clingmans Dome is a popular destination in Great Smoky Mountains National Park. It has always been interesting for travelers to keep a record of cars from other states when on vacation, and the parking lot at Clingmans Dome is a great place for license plate hunting. This linen-finish postcard probably dates from the 1930s.

WOODEN OBSERVATION TOWER. This linen-finish postcard probably dates from soon after the tower's construction in 1937. This wooden tower was built atop Clingmans Dome by Camp Kephart, Company No. 411 of the Civilian Conservation Corps, according to *Clingmans Dome: Highest Mountain in the Smokies* by Susan Spencer. The tower became unsafe by 1950, and it was dismantled.

525—Observation Tower on Clingman's Dome

Highest Peak in the Great Smoky Mountains National Park

CLINGMANS DOME OBSERVATION TOWER. This observation tower on top of Clingmans Dome was constructed in 1959 a half mile uphill from the parking area. Mount Le Conte is in the background in this picture. This glossy postcard shows early damage done to the Fraser firs by the balsam woolly adelgid, so it probably dates from about 1970.

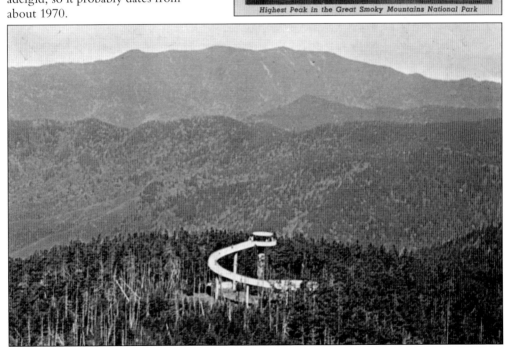

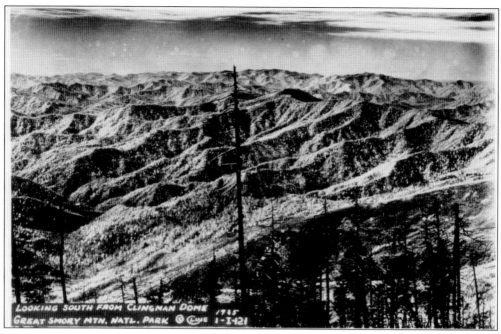

Looking South from Clingman Dome
Great Smoky Mtn. Natl. Park 1935 1-1-121

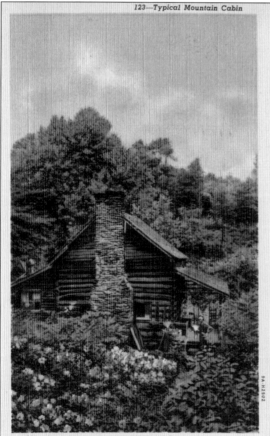

123—Typical Mountain Cabin

LOOKING SOUTH FROM CLINGMANS DOME. With an elevation of 6,643 feet, Clingmans Dome is the highest peak in Great Smoky Mountains National Park and the highest point along the Appalachian Trail that stretches from Maine to Georgia. The black-and-white photograph from which this postcard was made was taken in 1935.

MOUNTAIN LOG CABIN. There were as many different log cabin layouts in the 1800s as there were people building them. Trees were a plentiful resource, and mountain settlers knew how to construct their own cabins and other necessary farm buildings. Many of the cabins were supported by pillars made of piles of rocks with no mortar. This linen-finish postcard was postmarked in 1943.

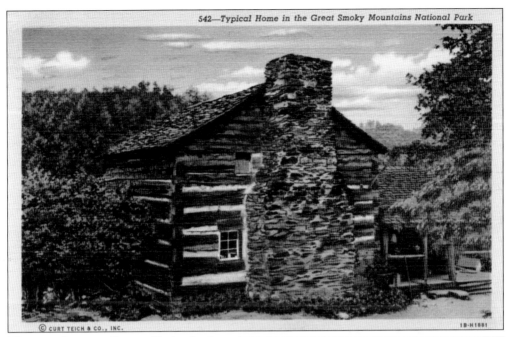

542—Typical Home in the Great Smoky Mountains National Park

© CURT TEICH & CO., INC. 1B-H1881

WALKER SISTERS CABIN. Dating back to the 1850s or before, this log cabin was constructed of hewn logs with half-dovetail notching. It was lived in by the Walker sisters in the Sevier County, Tennessee, portion of Great Smoky Mountains National Park until the last of them died in 1964. The cabin is in the National Register of Historic Places. This linen-finish postcard was postmarked in 1943.

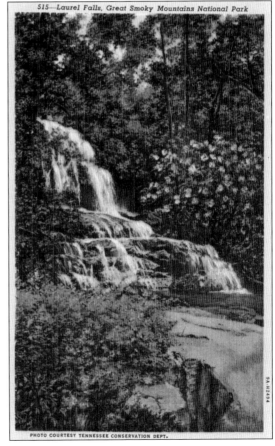

515—Laurel Falls, Great Smoky Mountains National Park

PHOTO COURTESY TENNESSEE CONSERVATION DEPT.

LAUREL FALLS. The upper and lower falls of Laurel Falls are visible in this picture with pink rhododendrons blooming to the right. This linen-finish postcard probably dates back to the 1930s. One of the most accessible waterfalls in Great Smoky Mountains National Park, Laurel Falls is a 1.3-mile hike from a parking area on Little River Road.

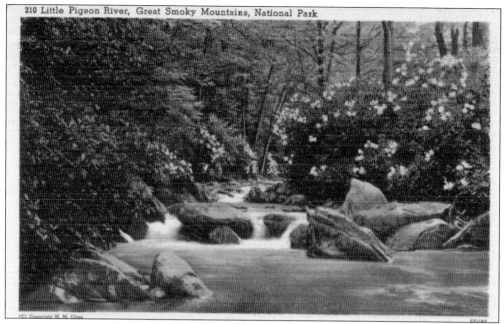

210 Little Pigeon River, Great Smoky Mountains, National Park

(C) Copyright W. M. Cline

LITTLE PIGEON RIVER. This linen-finish postcard was postmarked in 1949. The river forms along the state line in Great Smoky Mountains National Park and lies entirely in Sevier County, Tennessee. It flows into the French Broad River, which joins the Holston River near Knoxville. That confluence is considered to be the start of the Tennessee River.

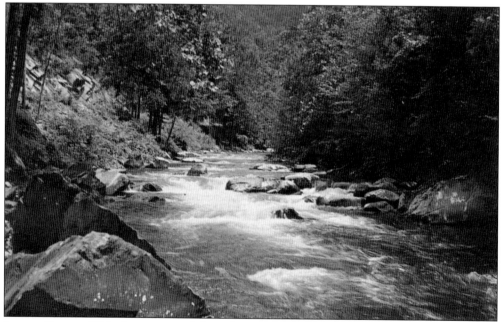

LITTLE RIVER. This glossy postcard dates from the mid-1950s. It reads as follows: "Tennessee highway #73 for more than 13 miles follows this beautiful stream through a rocky steep gorge between Elkmont and Townsend, Tennessee." Tennessee Highway 73 is now Little River Road. The Little River starts on Clingmans Dome, and the portion within Great Smoky Mountains National Park is protected from any degrading activities.

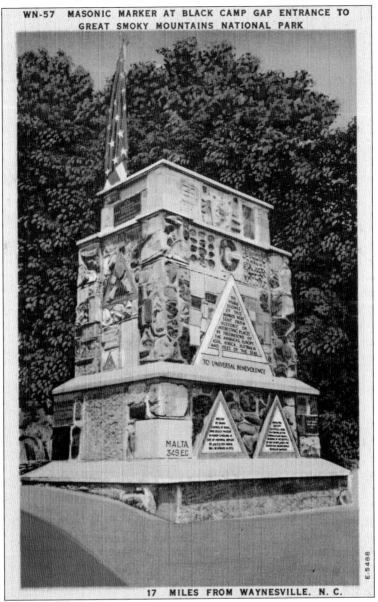

17 MILES FROM WAYNESVILLE. N. C.

MASONIC MARKER AT BLACK CAMP GAP. The back of this linen-finish postcard reads as follows: "Erected by Grand Council of Royal and Select Masters in North Carolina at site of Memorial Deposit, which will be opened in 1972. Dedicated July 11th, 1938 'as a symbol of the eternal flame which working in the depths of our hearts forms the stones for the brotherly temple of mankind.' The 500 visible stones of this marker were sent from historic or interesting places by Freemasons of America, Europe, Asia, Africa, Australia, and Isles of the Seas." Black Camp Gap Road turns off US Highway 19 near the Blue Ridge Parkway in Haywood County. It goes but a short distance into Great Smoky Mountains National Park to the Mile High Heintooga Overlook. A National Park Service history (in the Historic American Engineering Record series) of the spur road to Black Camp Gap can be found online. According to the www. phoenixmasonry.org website, the Memorial Deposit (box) referenced above was opened in 1972, and the Masonic memorabilia contained in it was displayed in Waynesville Masonic Lodge.

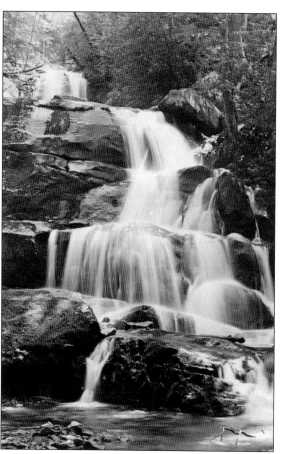

BEAUTIFUL LAUREL FALLS.
According to the National Park Service website, Laurel Falls is named for mountain laurel. An evergreen shrub, mountain laurel blooms near the falls in May. The hiking trail to the falls is the longest paved trail in Great Smoky Mountains National Park. This is a glossy postcard from about 1960.

RHODODENDRON IN THE PARK.
Catawba rhododendrons grow wild in the mountains of North Carolina and Great Smoky Mountains National Park. The blossoms are five to six inches across and lilac purple to pale lavender pink in color. Evergreen members of the azalea family, they bloom in the summer. This linen-finish postcard was postmarked in 1945.

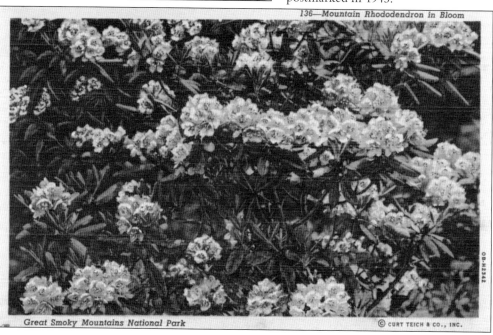

136—Mountain Rhododendron in Bloom

Great Smoky Mountains National Park

© CURT TEICH & CO., INC.

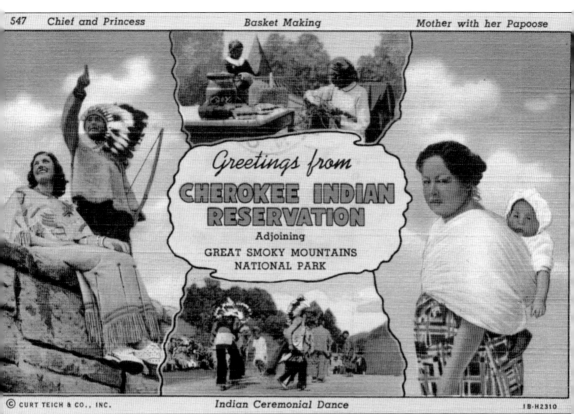

© CURT TEICH & CO., INC. *Indian Ceremonial Dance* 1B-H2310

GREETINGS FROM CHEROKEE. This linen-finish postcard, postmarked in 1954, depicts four scenes identified as follows: chief and princess, basket making, Indian ceremonial dance, and mother with her papoose. Three of the scenes are authentic, and the other one was posed. Basket making is still a skill practiced by the Cherokee people. Ceremonial dances are performed on special occasions. A papoose is the apparatus used to hold an infant, not the child. The chief and princess picture is not accurate. According to the Cherokee Museum website, "The Cherokee never had princesses. This is a concept based on European folktales and has no reality in Cherokee history and culture. In fact, Cherokee women were very powerful. They owned all the houses and fields, and they could marry and divorce as they pleased. Kinship was determined through the mother's line. Clan mothers administered justice in many matters. Beloved women were very special women chosen for their outstanding qualities. As in other aspects of Cherokee culture, there was a balance of power between men and women. Although they had different roles, they both were valued."

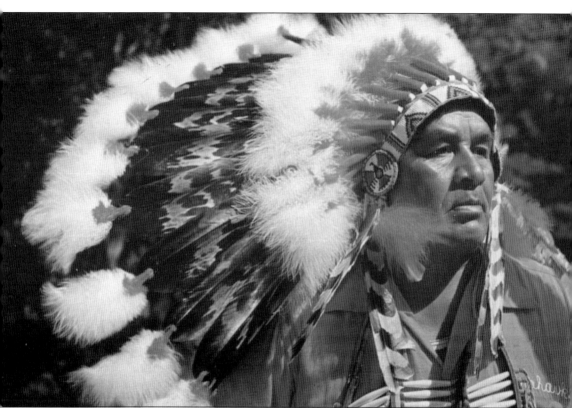

JESSE J. LOSSIE, CHEROKEE INDIAN. This postcard dates from about 1960 and perpetuated a misconception. According to the Cherokee Museum website, "The Cherokee have never worn feather headdresses except to please tourists. . . . In the early 18th century, Cherokee men wore cotton trade shirts, loincloths, leggings, front-seam moccasins, finger-woven or beaded belts, multiple pierced earrings around the rim of the ear, and a blanket over one shoulder. At that time, Cherokee women wore mantles of leather or feathers, skirts of leather or woven mulberry bark, front-seam moccasins, and earrings pierced through the earlobe only. By the end of the 18th century, Cherokee men were dressing much like their white neighbors. Men were wearing shirts, pants, and trade coats, with a distinctly Cherokee turban. Women were wearing calico skirts, blouses, and shawls. Today Cherokee people dress like other Americans, except for special occasions, when the men wear ribbon shirts with jeans and moccasins, and the women wear tear dresses with corn beads, woven belts, and moccasins." One can tell that Lossie, a World War II veteran, was proud of his Cherokee heritage.

CHEROKEE INDIAN WITH BOW AND ARROW. Contrary to this 1940s postcard, the Cherokee Museum website states, "The Cherokee have never worn feather headdresses except to please tourists. These long headdresses were worn by Plains Indians and were made popular through Wild West shows and Hollywood movies. Cherokee men traditionally wore a feather or two tied at the crown of the head."

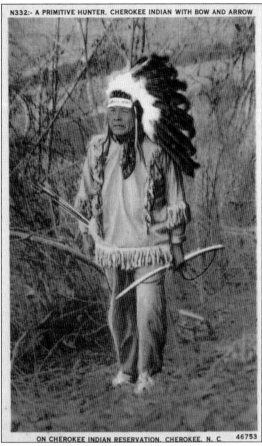

N332:- A PRIMITIVE HUNTER, CHEROKEE INDIAN WITH BOW AND ARROW

ON CHEROKEE INDIAN RESERVATION, CHEROKEE, N. C. 46753

CHEROKEE BASKET WEAVING. This postcard was postmarked in 1946. The woman appears to be mending a pair of trousers, and the man is weaving a flat-weave basket. Basket weaving is a centuries-old Cherokee art form. According to the www.Cherokee.org website, split oak and river cane are used for flat-weave containers.

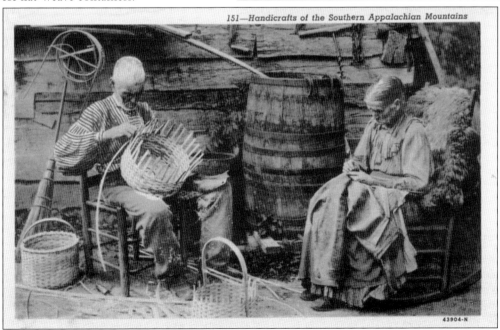

151—Handicrafts of the Southern Appalachian Mountains

43904-N

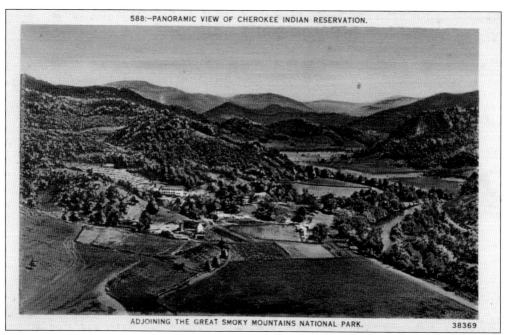

588:–PANORAMIC VIEW OF CHEROKEE INDIAN RESERVATION.

ADJOINING THE GREAT SMOKY MOUNTAINS NATIONAL PARK.

38369

PANORAMIC VIEW OF QUALLA BOUNDARY. This linen-finish postcard that was purchased in 1939 helps to dispel a false assumption about the Cherokee. The Cherokee Museum website states, "The Cherokee never lived in tipis. Only the nomadic Plains Indians did so. . . . Today the Cherokee live in ranch houses, apartments, and trailers."

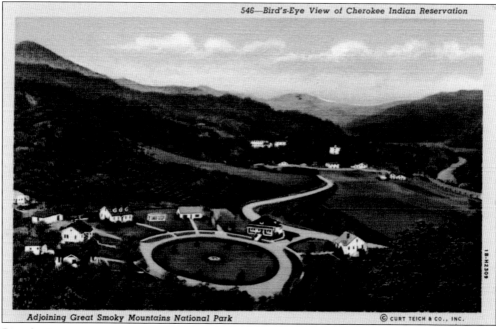

546—Bird's-Eye View of Cherokee Indian Reservation

Adjoining Great Smoky Mountains National Park

© CURT TEICH & CO., INC.

BIRD'S-EYE VIEW OF QUALLA BOUNDARY. The Cherokee Museum website states, "The Cherokee were southeastern woodland Indians, and in the winter they lived in houses made of woven saplings, plastered with mud and roofed with poplar bark. In the summer they lived in open-air dwellings roofed with bark." This is a linen-finish postcard.

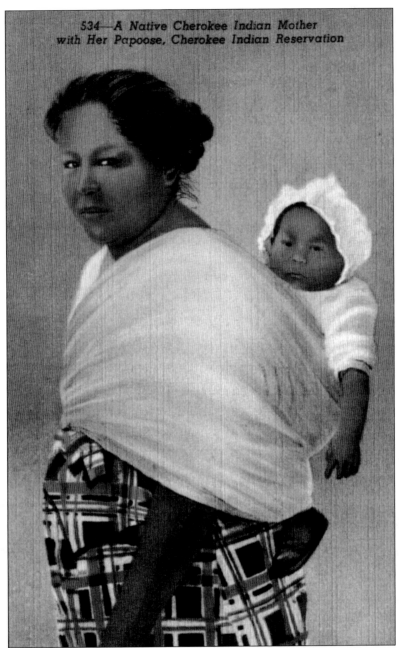

534—A Native Cherokee Indian Mother with Her Papoose, Cherokee Indian Reservation

CHEROKEE INDIAN MOTHER WITH BABY. The title printed on this postcard contains two misconceptions. It is just one of many postcards that incorrectly identify the Qualla Boundary as the Cherokee Indian Reservation. A reservation is land that the US government gives to an American Indian tribe. The Qualla Boundary is 57,000 acres of land purchased by the Cherokee Indians in the 1800s and held in trust by the US government. The other misconception in the title printed on the front of the postcard is that of calling a Cherokee baby a papoose. The Cherokee Indians find the use of the word offensive. A papoose is a type of bag or apparatus for carrying a child. A cradleboard is another such apparatus. It is made of wood, animal hides, and fur. This linen-finish postcard was postmarked in 1947.

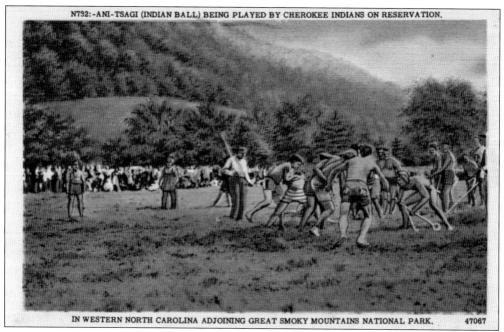

IN WESTERN NORTH CAROLINA ADJOINING GREAT SMOKY MOUNTAINS NATIONAL PARK. 47067

CHEROKEE BALL GAME. This linen–finish postcard was postmarked in 1950. It shows Cherokee Indians playing Indian ball. Called *ani-tsagi* on the postcard, the modern spelling is *anetso*. The game dates back hundreds of years and was possibly taken even more seriously than modern–day professional sports. Several books have been written about the game.

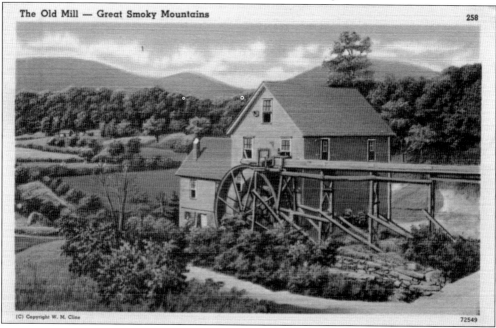

The Old Mill — Great Smoky Mountains 258

(C) Copyright W. M. Cline 72549

THE OLD MILL NEAR CHEROKEE. The gristmill pictured in this linen–finish postcard was built in 1886 between Cherokee and Whittier in Swain County, North Carolina. It is located on US Highway 441. A craft fair every summer at the Old Mill attracts visitors to see stone and wood carvers, blacksmiths, jewelry makers, and gourd artists from the Appalachian Mountains.

EARLS COTTAGES AND RESTAURANT. On US Highway 19, Earls Cottages and Restaurant in the Ela community between Cherokee and Bryson City was typical of mountain accommodations into the 1960s. Mrs. E.J. Earls was the owner and operator of Earls Cottages and Restaurant. This glossy postcard dates from 1961. The telephone number on the back of the card is only four digits.

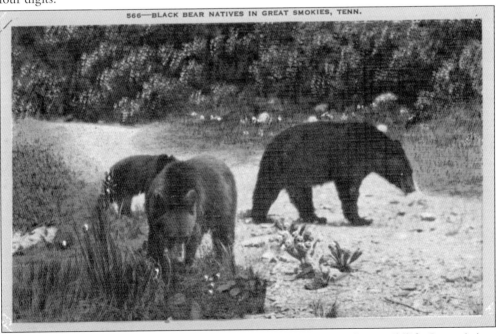

THREE BEARS IN THE SMOKIES. According to the North Carolina Wildlife Commission, black bears are found in more than half of North Carolina. Great Smoky Mountains National Park and the Cherokee area are some of the best places in the state to see a black bear. This is a linen–finish postcard.

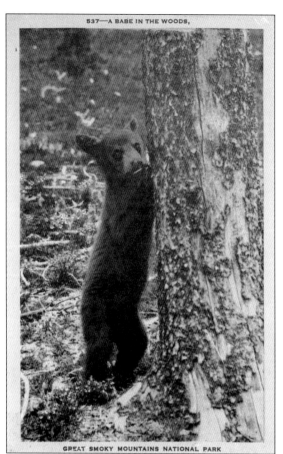

537—A BABE IN THE WOODS,

GREAT SMOKY MOUNTAINS NATIONAL PARK

BEAR CUB IN GREAT SMOKIES.
Commercial and residential development since Colonial times has resulted in a decrease in the black bear population in North Carolina. The American chestnut blight in the 1920s severely threatened the existence of the black bear in the mountains because the chestnut was an important component of their diet.

FOREST HABITAT FOR BLACK BEARS.
Black bears prefer to live and roam in large areas of uninhabited forest. They hibernate in winter in hollow logs, caves, and the cavities of live trees, making nests of leaves, sticks, and grass, according to the North Carolina Wildlife Commission website. This is a linen-finish postcard.

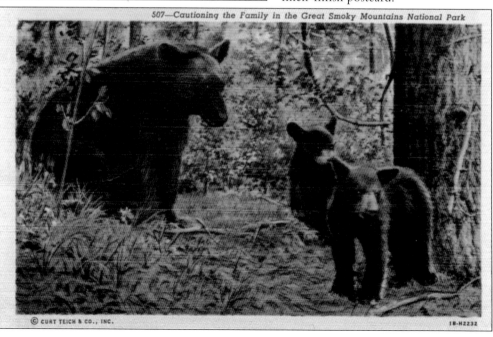

507—Cautioning the Family in the Great Smoky Mountains National Park

© CURT TEICH & CO., INC.

IB-H2232

Five

SNOWBIRD MOUNTAINS AND SOUTHWESTERN CORNER OF NORTH CAROLINA

Cherokee, Clay, and Graham Counties make up the southwestern corner of North Carolina. The Snowbird Mountains, a subrange of the Appalachian Mountains, are a cross range of mountains just south of Great Smoky Mountains National Park. This rugged area was long the hunting grounds of the Cherokee Indians.

The Snowbird area was purchased by the US government in 1943 and became part of the Nantahala National Forest. Hiking trails abound in the area, and streams such as Snowbird Creek are rich in several species of trout.

Some of the Cherokee people hid in these mountains during the Trail of Tears removal of the Cherokee to the Oklahoma Territory in 1838. Several hundred of their descendants live in the Little Snowbird community. Cherokee chief Junaluska's grave is in the town of Robbinsville in Graham County.

The Nantahala River attracts whitewater rafters from around the world. Nantahala, the Cherokee name for the gorge, translates as "Land of the Noon-Day Sun." It is so named because some of the depths of the eight-mile-long gorge only receive sunlight a short time in the middle of the day.

The area is home to a number of manmade lakes, including Fontana, Santeetlah, Cheoah, and Calderwood.

The Cherohala Skyway, completed in 1996, offers vistas that rival those along the Blue Ridge Parkway. An 11-mile portion of US Highway 129 is known as Tail of the Dragon due to its 318 curves.

TREES

I THINK THAT I SHALL NEVER SEE
A POEM LOVELY AS A TREE.

A TREE WHOSE HUNGRY MOUTH IS PREST
AGAINST THE EARTH'S SWEET FLOWING
BREAST.

A TREE THAT LOOKS AT GOD ALL DAY
AND LIFTS HER LEAFY ARMS TO PRAY.

A TREE THAT MAY IN SUMMER WEAR
A NEST OF ROBINS IN HER HAIR.

UPON WHOSE BOSOM SNOW HAS LAIN;
WHO INTIMATELY LIVES WITH RAIN.

POEMS ARE MADE BY FOOLS LIKE ME,
BUT ONLY GOD CAN MAKE A TREE.
— Joyce Kilmer

PHOTOS COURTESY—SOUTHERN REGION,
U. S. FOREST SERVICE

JOYCE KILMER MEMORIAL FOREST. This linen-finish postcard, postmarked in 1949, features Joyce Kilmer's poem "Trees." The Joyce Kilmer-Slickrock Wilderness contains 13,000 acres in the Snowbirds area. It was named for Joyce Kilmer, a 165th Infantry, Rainbow Division, soldier and poet who was born in New Brunswick, New Jersey, on December 6, 1886, and was killed in action in France on June 30, 1918. The Joyce Kilmer Memorial Forest within that wilderness area was dedicated in 1935 in Graham County and consists of 3,800 acres of timberland near Great Smoky Mountains National Park. The forest includes one of the largest groves of old-growth trees in the Eastern United States. Some of the trees are more than 400 years old and in excess of 20 feet in circumference. Some of the largest of the trees are hemlocks, red oaks, and poplars.

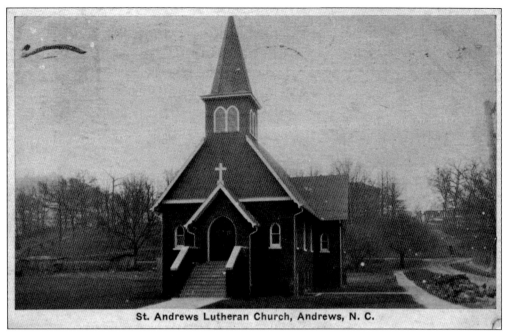

St. Andrews Lutheran Church, Andrews, N. C.

ST. ANDREW LUTHERAN CHURCH. This is the 1928 sanctuary of the St. Andrew Lutheran Church in Andrews. It was started in 1924 by the F.P. Cover family and is a member of the North Carolina Synod of the Evangelical Lutheran Church in America. The sanctuary has a Moeller pipe organ. This black–and–white matte-finish postcard was postmarked in 1939.

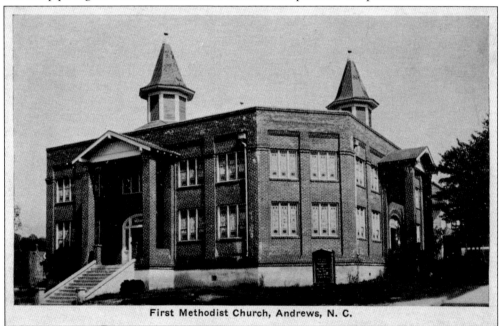

First Methodist Church, Andrews, N. C.

FIRST METHODIST CHURCH. First Methodist Church in the town of Andrews was established in 1920 and is located at 101 Chestnut Street. The name is now Andrews United Methodist Church. It is part of the Western North Carolina Conference of the United Methodist denomination. This is a matte-finish black–and–white postcard.

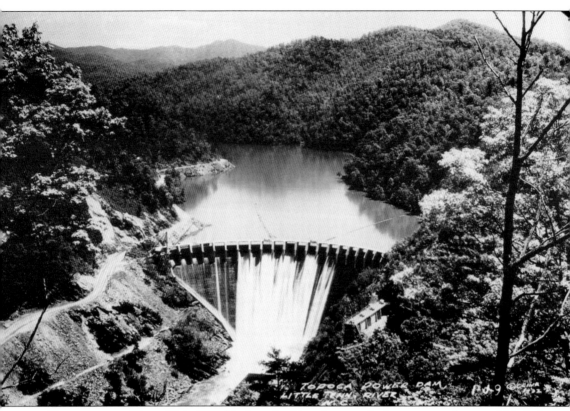

THE CHEOAH DAM. This 1932 black-and-white glossy real-photo postcard was mislabeled as Topoca Dam. Construction on the dam on Little Tennessee River, in Graham County, began in 1916. Completed in 1919, the dam helped form the Cheoah Reservoir. The reservoir covers 644 acres and has an elevation of 1,277 feet. NC Highway 28 and US Highway 129 pass Fontana Lake, Cheoah Lake and Dam, Santeetlah Lake and Dam, and pass through the town of Robbinsville before ending at US Highway 19/74 just south of Nantahala Gorge. Portions of the highway were designated as Indian Lakes Scenic Byway by the North Carolina Department of Transportation in 1994. The Cheoah Dam was used in the 1993 movie *The Fugitive*, starring Harrison Ford. The movie's most memorable scene took place on top of Cheoah Dam. *Cheoah* is the Cherokee word for "otter."

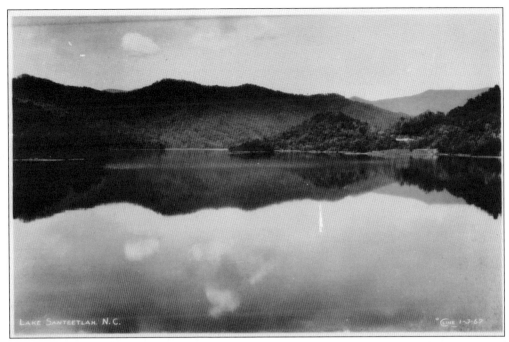

LAKE SANTEETLAH IN GRAHAM
COUNTY. This is a black-and-white
glossy real-photo postcard from the
1930s. Lake Santeetlah was formed by the
Santeetlah Dam on the Cheoah River.
The dam is 225 feet high and 1,054 feet
long. It was the world's tallest overflow
dam when it was completed in 1928.

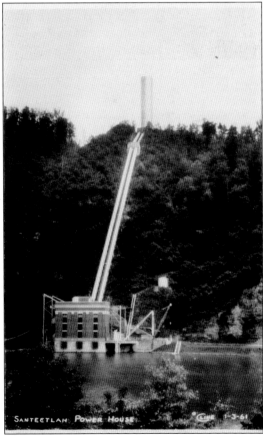

SANTEETLAH POWERHOUSE. The
Santeetlah Powerhouse at Rhymer's
Ferry, on the Little Tennessee River,
started generating hydroelectric power
in 1928. The Santeetlah Dam's turbines
were the largest in the world when
installed, and its transmission line carried
the highest voltage and longest span of
any across the Little Tennessee River.
This black-and-white glossy real-photo
postcard dates from the 1930s.

101

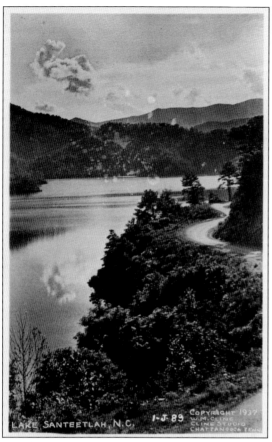

LAKE SANTEETLAH. These are 1937 black-and-white real-photo postcards. The American Rivers website states: "When the Tallassee Power Company (or TAPOCO) closed the gates on the Santeetlah Dam in 1928, North Carolina's Cheoah River vanished. For nearly 75 years, the riverbed was almost completely dry. At the Santeetlah Dam, the Cheoah's entire flow disappeared into a steel pipe that cut through a mountain to a powerhouse on the banks of the Little Tennessee River." But in 2004, Alcoa Power Generating, Inc., which had purchased the dam, "signed a landmark agreement with American River, Tennessee Clean Water Network, The Nature Conservancy, National Parks Conservation Association, Sierra Club, local communities and property owners, the states of Tennessee and North Carolina, the National Park Service, USFWS [United States Fish and Wildlife Service], the Bureau of Indian Affairs, and the United States Forest Service."

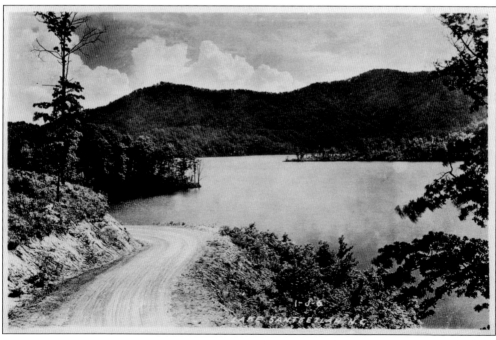

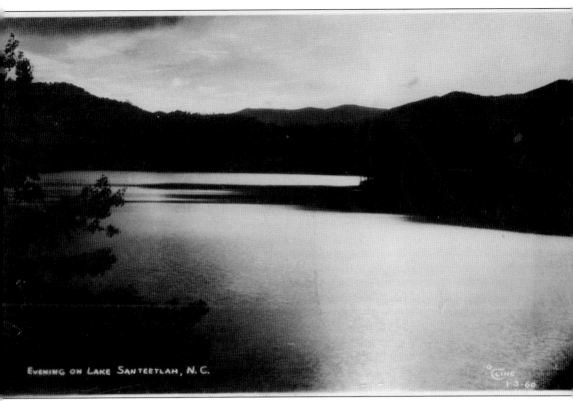

EVENING ON LAKE SANTEETLAH, N. C.

EVENING ON LAKE SANTEETLAH. According to the American Rivers website, in the 2004 agreement (referenced on the preceding page of this book), all stakeholders "agreed to support a new 40-year operating license for Alcoa's TAPOCO project. In exchange, Alcoa agreed to changes that would protect 10,000 acres of pristine watershed lands adjacent to Great Smoky Mountains National Park, enhance four endangered fish species, put water back into two previously dry stretches of river, and provide more than $12 million for conservation projects and enhanced recreational facilities. The agreement restored flow to two river reaches from which dams had diverted water, including the Cheoah. Restoring natural flow patterns to this stretch of river has already improved its diverse native aquatic life, helping species like the endangered Appalachian Elktoe mussel to make a comeback." The Tallassee Watershed Trust Fund and a North Carolina Fund were set up by Alcoa to provide funds to address Little Tennessee watershed problems and preservation efforts. The TAPOCO project now belongs to Brookfield Smoky Mountain Hydropower. This black-and-white glossy real-photo postcard dates from the 1930s.

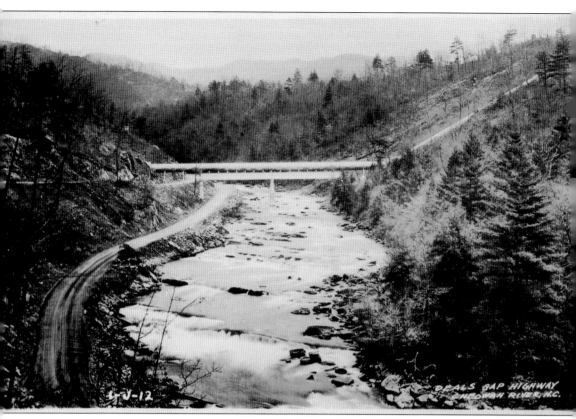

DEAL'S GAP ROAD. This black-and-white real-photo postcard dates from the 1930s. The Tallassee Power Company had constructed a railroad connecting its various projects. J.S. Barrett wrote the following in his "History of Tapoco," found on the www.GrahamCounty. net website: "In 1929 Tallassee Power Company transferred the railroad bridge across the Little Tennessee, below the mouth of Cheoah River and the construction railroad grade to Santeetlah Dam to the N.C. Highway Commission. These were converted to part of N.C. 108 (later US 129) which was completed to Deal's Gap in 1931 to make connection to N.C. 288 to Bryson City and Tennessee 72 to Marysville and Knoxville, Tennessee. Tapoco's isolation was removed with the completion of this highway and also to some extent for Graham County. This was the beginning of the tourist trade." Deal's Gap is where NC Highway 28 intersects with US Highway 129 today, some 11 miles west of Fontana Dam and just east of the North Carolina-Tennessee state line.

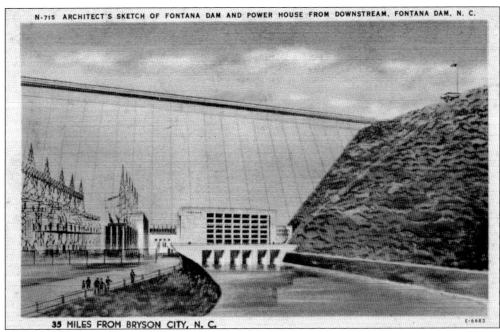

N-715 ARCHITECT'S SKETCH OF FONTANA DAM AND POWER HOUSE FROM DOWNSTREAM, FONTANA DAM, N. C.

35 MILES FROM BRYSON CITY, N. C.

ARCHITECT'S SKETCH OF FONTANA DAM. The description on the back of this linen-finish postcard reads in part as follows: "TVA's Fontana Dam, Architect's sketch showing how Fontana Dam will look when it is completed early in 1944. The dam is being speeded to completion under emergency schedules so that additional power may be available for war industries."

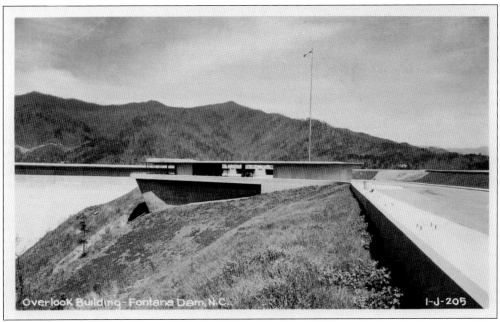

Overlook Building - Fontana Dam, N.C.

FONTANA DAM OVERLOOK BUILDING. This is a glossy black-and-white real-photo postcard. At 480 feet tall, Fontana Dam is the tallest dam east of the Rocky Mountains. Built at a cost of nearly $70.5 million, the dam was originally planned to provide electric power for the United States' World War II effort. It now provides electric power to a wide area.

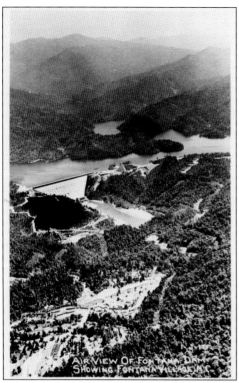

AERIAL VIEW OF FONTANA DAM. This is a glossy black-and-white real-photo postcard of the .5-mile-wide dam. Its three generating units have a net dependable capacity of 304 megawatts. The water level of the lake varies approximately 56 feet between summer and winter due to precipitation and flood-control measures.

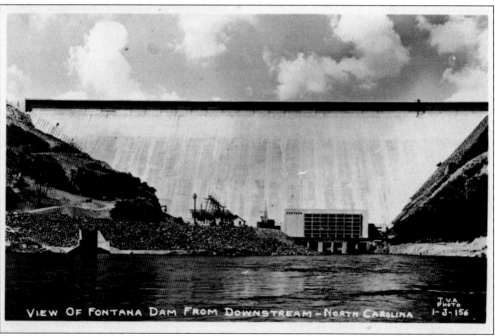

FONTANA DAM FROM DOWNSTREAM. This dam on the Little Tennessee River in Swain and Graham Counties was completed in 1946. Fontana Dam holds back an 11,700-acre lake that borders Great Smoky Mountains National Park on the north and Nantahala National Forest on the south. This is a glossy black-and-white real-photo postcard.

FONTANA DAM AND POWERHOUSE. This is a glossy black-and-white real-photo postcard. Construction of Fontana Dam and the resulting Fontana Lake necessitated the relocation of 1,311 families, 1,047 graves, and more than 60 miles of roads, according to *The Fontana Project: A Comprehensive Report on the Planning, Design, Construction, and Initial Operations of the Fontana Project, Technical Report No. 12*, published in 1950.

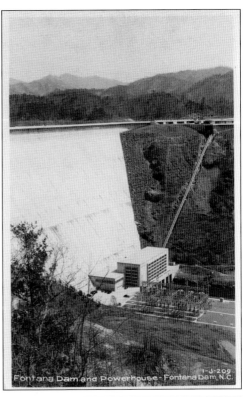

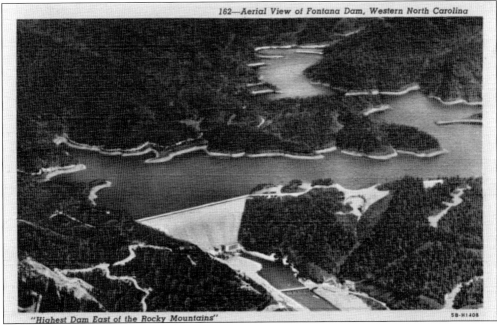

FONTANA DAM FROM THE AIR. This linen-finish postcard was postmarked in 1950. The description on the back of the card states that Fontana Dam was "the fourth highest dam in the world" and "three million cubic yards of concrete were used in constructing it." The Appalachian Trail crosses the top of the dam.

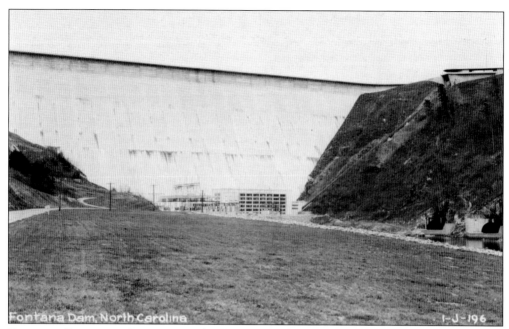

FONTANA DAM WITH SPILLWAYS. This black-and-white glossy real-photo postcard is different from the other views of Fontana Dam in this book because it includes the spillways to the right of the dam. According to the www.tva.gov/heritage/fontana.htm website, the massive Fontana Dam required extraordinary spillways that are 34 feet in diameter.

A VIEW OF FONTANA LAKE. Fontana Lake is 30 miles long and provides boating and fishing opportunities to the public. The lake covers 11,700 acres. It borders Great Smoky Mountains National Park on the north and Nantahala National Forest on the south. This glossy postcard bears a 1961 Fontana Dam postmark.

BEAUTIFUL FONTANA LAKE. Fontana Lake was formed when the Tennessee Valley Authority built the Fontana Dam on the Little Tennessee River in Graham and Swain Counties, North Carolina. According to the www.tva.gov/heritage/fontana.htm website, the lake has 238 miles of shoreline. This is a glossy postcard that probably dates from the 1960s.

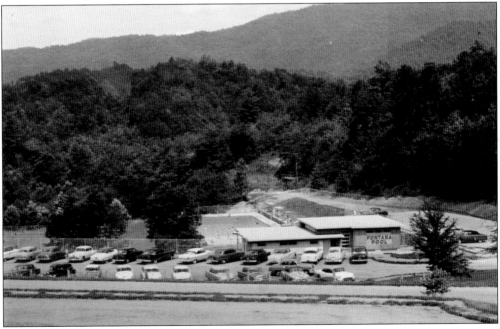

SWIMMING POOL AT FONTANA VILLAGE. This is a glossy postcard from the mid–1950s. Fontana Resort Village offers a range of accommodations, dining facilities, and recreation opportunities for all ages. This pool was 50 feet by 100 feet with an adjoining children's pool and was located near the boat dock. Both pools were heated.

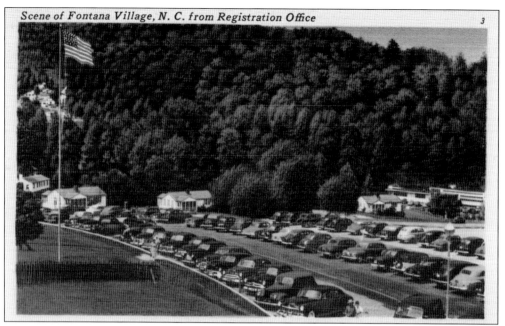

FONTANA VILLAGE FROM REGISTRATION OFFICE. From the automobiles in this picture, one can tell that this linen-finish postcard dates from the mid-1950s. The village was formed by the people who built the dam. More than 20 miles of hiking and mountain bike trails surround the village, which is a year-round tourist destination.

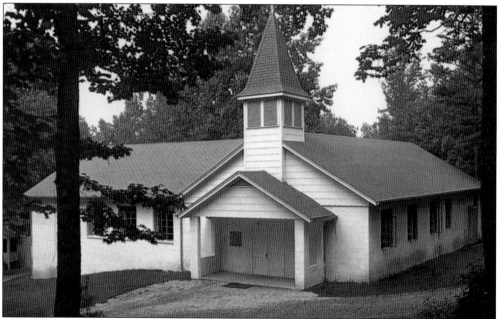

FONTANA COMMUNITY CHURCH. This nondenominational church was constructed to serve the families that remained in Fontana Village after the thousands of people who were brought in to build the dam moved away when their work was finished in 1946. A nondenominational church was formed due to the varied backgrounds of the residents. This glossy postcard was postmarked in 1961.

Six

LAND OF WATERFALLS

Henderson, southern Jackson, Macon, Polk, and Transylvania Counties form the southern part of the mountains of North Carolina between the Snowbird area and the foothills. Waterfalls are found throughout the mountains of North Carolina, but these counties have an abundance of them.

Dry, Bridal Veil, Cullasaja, Looking Glass, Pearson's, Toxaway, Burningtown, and Connestee Falls are a few of the dozens of waterfalls in the counties included in this chapter.

In addition to waterfalls, Sliding Rock attracts the young and the young-at-heart on hot summer days. It is nature's water slide. Visitors can slide all the way down this 50-foot rock over which Looking Glass Creek flows. Managed by the US Park Service, Sliding Rock is right beside US Highway 276, approximately eight miles north of the town of Pisgah Forest in Transylvania County.

Macon County is famous for the rocks, minerals, and precious gemstones found there.

Henderson County is home to the Carl Sandburg Home National Historic Site, Flat Rock Playhouse, the highest bridge in North Carolina, and thousands of acres of apple orchards.

Howard Gap, in Polk County, necessitates a steep grade for several miles on Interstate 26 near Saluda. Views from that grade are spectacular.

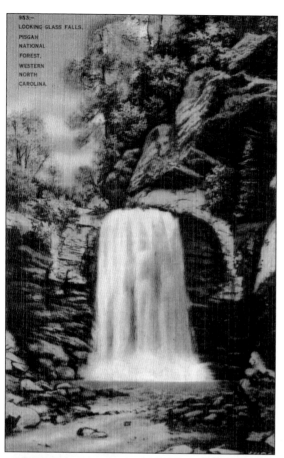

LOOKING GLASS FALLS. This linen-finish postcard was postmarked in 1943. This Transylvania County waterfall was so named due to the mirror or looking glass affect made in the winter when water freezes on the rock behind the falls. The water flowing over the falls is Looking Glass Creek in Pisgah National Forest.

BEAUTIFUL LOOKING GLASS FALLS. Looking Glass Falls is 60 feet high and one of the most visited waterfalls in North Carolina due to its beauty and accessibility. This waterfall is on US Highway 276 in Pisgah National Forest near Brevard. The photograph from which this postcard was made was taken in 1959.

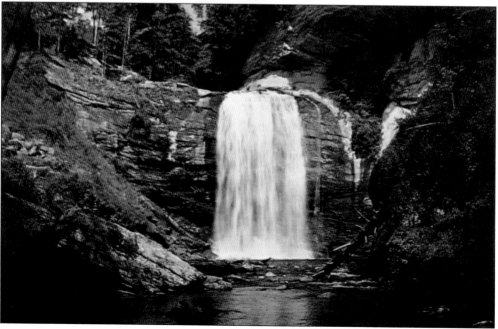

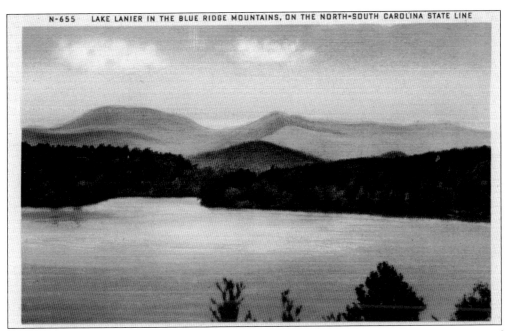

LAKE LANIER IN BLUE RIDGE MOUNTAINS. This is a linen-finish postcard. The town of Tryon in Polk County is just north of this 140-acre privately owned lake. Lake Lanier (not to be confused with the larger Lake Lanier in Georgia) was constructed in the 1920s on the North Carolina–South Carolina state line.

TRICEMONT TERRACE AT HIGHLANDS. The Four Freedoms 1¢ postage stamp on this linen-finish postcard bears a 1944 postmark. Henry Martin Bascom built this hotel at Highlands. It was known as Davis House, Tricemont Terrace, Kings Inn, Lee's Inn, and the Bascom-Louise Hotel before it was destroyed by fire in 1982. The hotel stood at an elevation of 4,000 feet and included five acres of grounds.

INDIAN MOUND NEAR FRANKLIN. This is all that remains of an ancient Cherokee town named Nikwasi in Macon County. Probably built between 800 and 1500 CE, the top of the mound was at one time home to the council house. Cherokee legend says that the spirit people lived beneath the mound, which is sacred ground to the Cherokee. This hand-colored postcard appears to be from the early 1900s.

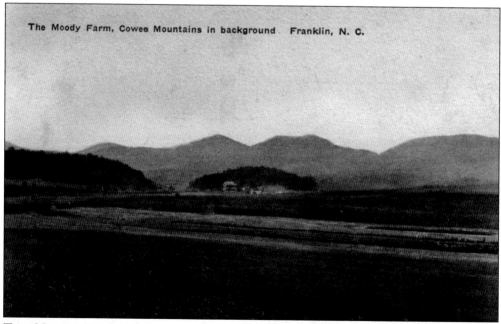

THE MOODY FARM. The Moody Farm was located on the road to Olive Hill in Macon County. The Cowee Mountains, seen in the background, are a range with a top elevation of 4,285 feet. Rich in precious minerals, the range lies between US Highway 441 and NC Highway 28. This hand-colored postcard from the early 1900s was produced by the Albertype Company, Brooklyn, New York.

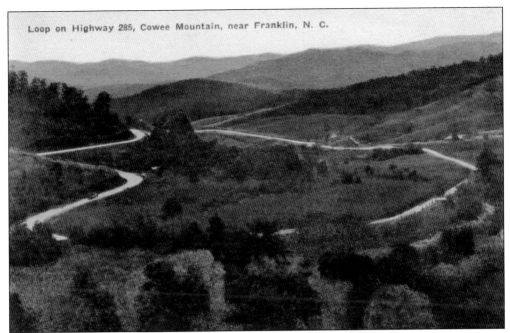

Loop on Highway 285, Cowee Mountain, near Franklin, N. C.

LOOP ON HIGHWAY 285, COWEE MOUNTAIN. On a 1930 Macon County road map, it appears that Highway 285 was a forerunner of present-day US Highway 23/US Highway 441, heading north-northeast out of Franklin. Many precious gems and minerals, such as rubies, sapphires, garnets, emeralds, amethyst, rose quartz, and smoky quartz, are mined in the area.

FUN AT CAMP TEKOA. The Western North Carolina Conference of the United Methodist Church owns Camp Tekoa. It is a camp for children and youth in the summer and a retreat facility the rest of the year. Camp Tekoa is located near Hendersonville in Henderson County. This textured glossy color postcard probably dates from the 1960s.

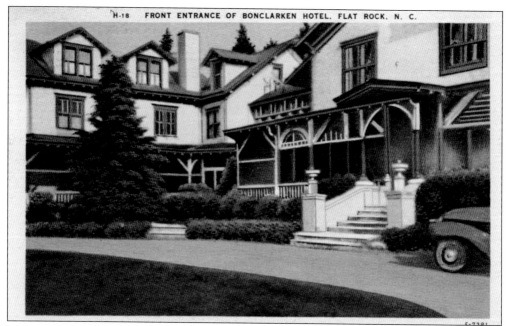

BONCLARKEN HOTEL FRONT ENTRANCE. Heidelberg Hotel in Flat Rock in Henderson County was built as a private residence in 1886. The home and 63 acres of Heidelberg Gardens were purchased in 1921 to be Bonclarken—the assembly grounds for the Associate Reformed Presbyterian Church. This postcard was postmarked in 1947.

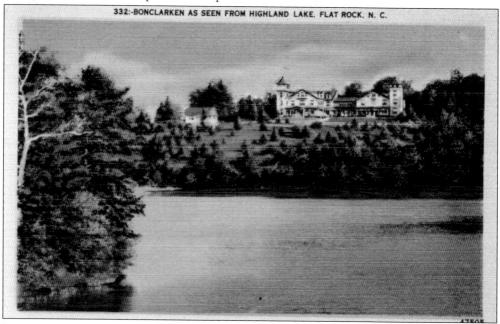

BONCLARKEN AS SEEN FROM HIGHLAND LAKE. Bonclarken Hotel is on the grounds of Bonclarken Christian Conference Center of the Associate Reformed Presbyterian Church. The name has the following three different parts: "Bon," which is bonus or good in Latin; "clar" from the Latin clarus for clear; and "ken," which is from the Scots word for vision. Thus, Bonclarken means good clear vision. This postcard bears a 1948 postmark.

Seven

FOOTHILLS

In North Carolina, there is a gradual transition between the mountains and the Piedmont. That transitional area is commonly called the foothills.

There is not a definitive line between the mountains and the foothills, so the divisions made in this book are subjective. This chapter includes the lower elevations of Burke, Caldwell, and Rutherford Counties.

Caldwell County has long been world-renown for quality furniture manufacturing but is now attracting the technology and cyber industry.

Burke County is home to an outdoor drama, *From This Day Forward*, about the Waldensians, a religious sect that emigrated from Italy and settled in Valdese. It is also home to the North Carolina School for the Deaf, Western Piedmont Community College, and Broughton Hospital.

Rutherford County runs the gamut in elevation from 806 feet at Caroleen to 3,967 feet at Sugar Loaf. The county's terrain ranges from gently rolling hills to the rugged Chimney Rock and Hickory Nut Gorge, which are covered in the Land of the Sky chapter of this book.

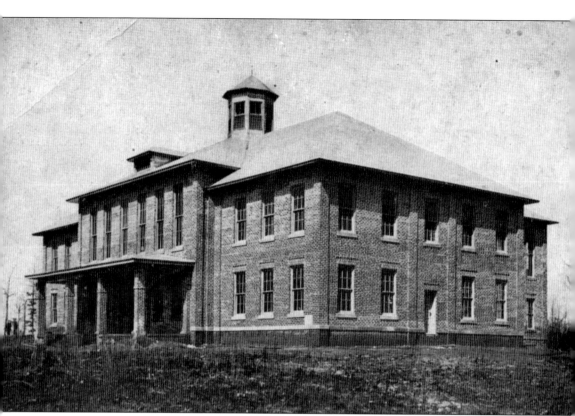

RUTHERFORD COLLEGE. According to the www.rutherfordcollegenc.us/history.html website, Burke County's Owl Hollow School in the Excelsior community became Rutherford Academy in the 1850s. The school was named for John Rutherford Jr. He was one of the wealthiest men in Burke County and a benefactor of the school. According to *Burke County: A Brief History*, by Edward W. Phifer Jr., the school was coeducational by 1857. In 1859, a student indicated in a letter that he was studying algebra, astronomy, rhetoric, and Latin at the school. Forced to close during the Civil War, it reopened in 1868 as Rutherford Seminary. The Western North Carolina Conference of the Methodist-Episcopal Church, South, purchased the school in 1899. It became Rutherford College and later merged with Weaver College and Brevard Institute to form Brevard College in Transylvania County. This postcard dates from the early 1920s.

Greetings from NORTH CAROLINA

MORGANTON

State Capitol in Raleig

State Flower
the Goldenrod

GREETINGS FROM MORGANTON. This linen-finish postcard was postmarked in 1945. Europeans first explored the area in 1566 when Spaniard Juan Pardo led an expedition and established Fort San Juan. Archeological work continues at the lost Catawba town of Joara (or Xualla) and at the site of the fort, according to *Spanish Attempts to Colonize Southeast North America, 1513–1587* by Larry Richard Clark. Morganton, the county seat of Burke County, was established in 1784 and named for Gen. Daniel Morgan of Revolutionary War fame. The first post office in Morganton opened in 1794, and the first courthouse was built there in 1874. The town was incorporated in 1839. Morganton was the home of Samuel "Sam" James Ervin Jr., a US senator from 1954 until 1974. Ervin is remembered as a strict constitutionalist and moderator of the Senate's Watergate hearings.

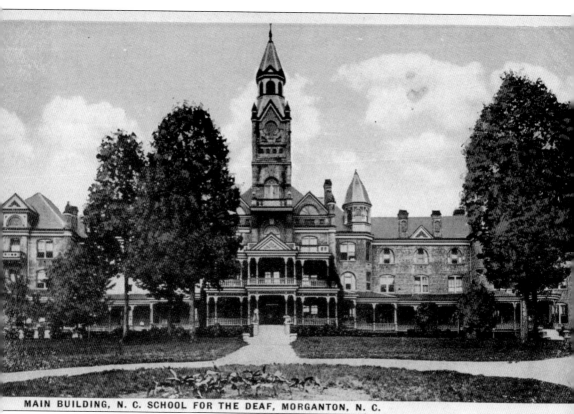

MAIN BUILDING, N. C. SCHOOL FOR THE DEAF, MORGANTON, N. C.

NORTH CAROLINA SCHOOL FOR THE DEAF. This matte-finish postcard is black-and-white except the sky is blue. The notation "sky tint" appears on the back. Becker's Variety Store in Morganton published this postcard. It is a view of the Main Building of the North Carolina School for the Deaf on the 160-acre campus in Morganton, and it appears to date from the early 1900s. The school was established in 1894. It operates as a day and residential facility. The school is dually accredited by the Conference of Educational Administrators Serving the Deaf and the Southern Association of Colleges and Schools. The school is a member of the North Carolina High School Athletic Association and the Mason Dixon Conference of Schools for the Deaf. Students compete in football, basketball, and volleyball. The renovated Main Building has dormitory rooms for the residential students.

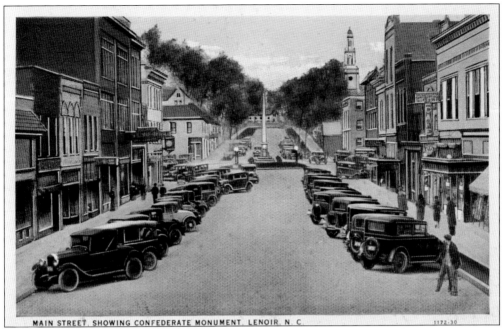

MAIN STREET, SHOWING CONFEDERATE MONUMENT, LENOIR, N. C. 1172-30

MAIN STREET LENOIR. This is a matte-finish postcard, which indicates that it predates 1930. The Confederate Monument in the center of the town square was built to the memory of Caldwell County's Confederate army veterans from the Civil War. This colorful postcard shows variety in storefronts and automobiles parked on the street.

L2:—MONUMENT SQUARE, LENOIR, N.C.

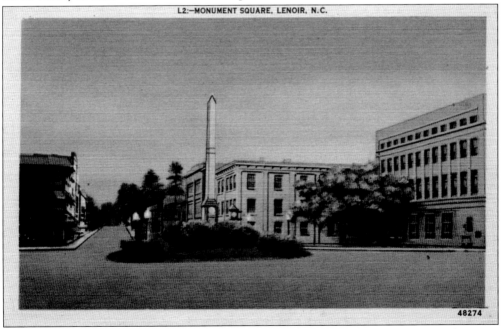

48274

MONUMENT SQUARE IN LENOIR. This is a linen-finish postcard. It is a closer depiction of Caldwell County's Confederate army veterans' monument. Lenoir is the county seat of Caldwell County and was originally called Tucker's Barn. The town was named for Gen. William Lenoir, a Revolutionary War veteran, teacher, and surveyor.

CALDWELL COUNTY COURTHOUSE. This linen-finish postcard was postmarked in 1958. Caldwell County was formed out of Burke and Wilkes Counties in 1841 and was named for Dr. Joseph Caldwell, a public school advocate, president of the University of North Carolina, and a driving force in getting a railroad through the county. Modern furniture factories started in 1889, and the furniture industry was the county's main employer for the next century. The county seat of Caldwell County is Lenoir. The elevation of Caldwell County ranges from 900 feet to nearly 6,000 feet. According to the www.blueridgeheritage.com website, Gen. William Lenoir built Fort Defiance on the banks of the Yadkin River to serve as a safe haven for European settlers against attacks by Cherokee Indians. He built his home on that same site between 1788 and 1792. The Lenoir family lived in the house until 1961. Tours of the restored house are available.

49056

BAPTIST CHURCH, LENOIR. Called First Baptist Church of Lenoir today, this church campus is at 304 Main Street NW in downtown Lenoir, located at the corner of Main Street and Ashe Avenue. It is part of the Missionary Baptist denomination. This linen-finish postcard was postmarked in either 1947 or 1957.

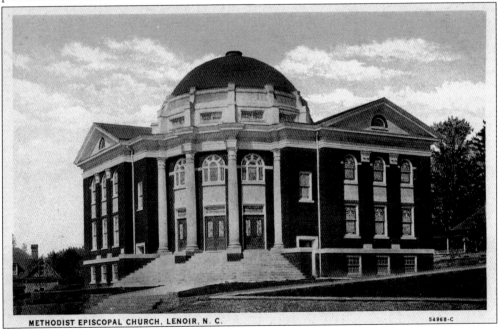

METHODIST EPISCOPAL CHURCH, LENOIR, N. C.

54968-C

METHODIST EPISCOPAL CHURCH. This is a matte-finish postcard. This church in Lenoir was established about 1846 and has remained at its original location at the corner of Ashe Avenue and Church Street. The church is located at 309 Church Street NW in Lenoir, Caldwell County. The name is now First United Methodist Church.

123

THE CARLHEIM HOTEL, LENOIR, N. C.

THE CARLHEIM HOTEL. This is a linen-finish postcard. The Carlheim Hotel stood at 318 Main Street NW in Lenoir and was torn down around 1970. In the early 1900s, Lenoir was a good overnight stop for people traveling from the Piedmont to the mountains. Travelers arriving in Lenoir late in the day were wise to spend the night before attempting to drive into the mountains.

M. E. CHURCH AND PARSONAGE, NORTH WILKESBORO, N. C.

METHODIST CHURCH AND PARSONAGE. This matte-finish postcard was postmarked in 1923. When this postcard was printed, the denomination of which this church in North Wilkesboro was a member was the Methodist Episcopal Church, South. After a series of denominational mergers, the name of the church became First United Methodist Church. The church's pastor lived in the parsonage.

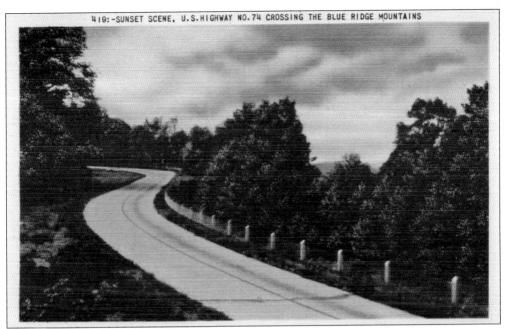

HIGHWAY 74 CROSSING THE BLUE RIDGE. This is a linen-finish postcard. US Highway 74 crosses the Blue Ridge Mountains in several foothills and higher mountain counties in North Carolina from Rutherford County to Cherokee County via Asheville, Waynesville, and Bryson City. At the time this postcard was manufactured, US Highway 74 meandered even more than it does today.

NORTH CAROLINA TOAST. This linen-finish postcard gives the first verse of the four-verse North Carolina State Toast. An article by Scott Huler in the January 2014 issue of *Our State* magazine states that the toast was adopted in 1957. It was a song written in 1904 by Leonora Martin and Mary Burke Kerr. North Carolina is the only state with an official state toast.

BIBLIOGRAPHY

Adams, Kevin. *North Carolina's Waterfalls: Where to Find Them, How to Photograph Them.* Winston-Salem, NC: John F. Blair, 1999.

Adkins, Leonard M. *Hiking and Traveling the Blue Ridge Parkway.* Chapel Hill, NC: The University of North Carolina Press, 2013.

BlueRidgeParkway.org

CherokeeMuseum.org

Frankenberg, Dirk. *Exploring North Carolina's Natural Areas: Parks, Nature Preserves, and Hiking Trails.* Chapel Hill, NC: The University of North Carolina Press, 2000.

gsmnp.com

https://archive.org/details/historyoffirstun00sloa

http://lcweb2.loc.gov/pnp/habshaer/tn/tn0200/tn0275/data/tn0275data.pdf

Houk, Rose. *Great Smoky Mountains National Park: A Natural History Guide.* NY: Houghton Mifflin, 1993.

Linzey, Donald. *Mammals of Great Smoky Mountains National Park, 4th ed.* Blacksburg, VA: McDonald & Woodward Publishing Company, 1995.

Lord, William G. *Blue Ridge Parkway Guide, rev. ed.* N.p.: Eastern Acorn Press, 1990.

nps.gov

Sehlinger, Bob, and Joe Surkiewicz. *The Unofficial Guide to the Great Smoky & Blue Ridge Region 3rd ed.* NY: Macmillan, 1999.

www.LakeJunaluska.com

INDEX